YOU AND YOUR CAMERA

YOU AND YOUR CAMERA

By the author of
YOU AND YOUR
LENSES

WILLIAM R. HAWKEN

AMPHOTO
American Photographic Book Publishing Co., Inc.
Garden City, N.Y. 11530

This book is for
my friends

4th Printing 1976

Copyright © 1973 by American Photographic Book Publishing Co., Inc.

Library of Congress Catalog Card No. 72-97052

ISBN 0-8174-0560-7
Manufactured in the United States of America.

CONTENTS

Figure 1. A typical 35mm single-lens reflex camera.

PREFACE

This book came to be written because of two conditions prevalent in the field of amateur photography today. The first is the widely felt need on the part of thousands of amateur photographers for simpler information about photography in general and their cameras in particular. This large group own cameras identical to those owned by professionals, but they are not professional photographers and often may have no background at all in the sciences on which photographic technology is founded. They are a group who need to take better advantage of the excellent quality inherent in the cameras they own. No book exists that explains in simple language the basic principles involved in creating an image in a camera or the functions of the various operating controls and the whys and wherefores behind them.

The second condition is the result of a trend over the past two decades toward a general and growing standardization in basic camera design. Whereas at one time hand cameras came in an endless variety of designs, today the type of hand camera known as the "eye-level 35mm single-lens reflex" camera has become pre-eminent the

9

world over. Above the level of the mere "snapshooting" camera, the "SLR" is the most popular and widely used camera among professionals and amateurs alike.

Models from various manufacturers differ in design details, in the location of certain controls, or in mechanical methodology. Nonetheless, the basic principles, operating features, and controls of SLR cameras are by now sufficiently similar to make feasible as well as desirable the compilation of this guide. It should be of value to all SLR owners, regardless of the make, model, or country of origin of their cameras.

This book in no way will be concerned with the esoteric complexities of photographic technology nor the abstruse language concerned with *refractive indices, conjugate foci, gamma infinity,* or the diameter of the *circle of confusion.* Confusion must be dispensed with; clarity and simplicity are the intended goals.

Also, this book is not a book about camera mechanics: how to open and close your camera; how to load and unload film; how to change lenses; how to attach a flash attachment; or even how to take it out of the case and put it back again. These points should be explained by the dealer who sold you the camera or described in the owner's manual that came with your camera. Besides, no two single-lens reflex cameras are exactly alike in such details and to describe the procedures for each and every one would be an encyclopedic and wasteful exercise.

This book is about camera *functions* that are common to all cameras. Hence, it is also applicable to those cameras which are not of the single-lens reflex design. This book is about the basic principles and concepts of photography, and how to use them to the highest degree of effectiveness.

The main theme of this book is *understanding.* This, however, will not involve you in a difficult intellectual exercise. On the contrary, the goal is to demonstrate that understanding your camera and its functions is easily attainable in a field that only *appears* to be strange, "technical," and seemingly difficult to comprehend. The unfamiliar can become familiar; the cobwebs of bewilderment can be swept aside to make room for clarity; frustration can be replaced with satisfaction; and with understanding will come enjoyment and mastery.

The purpose of this book can be summed up as an attempt to translate the technical into the understandable for all who would like to exploit with freedom and enjoyment the remarkable capabilities inherent in modern hand cameras.

I am indebted to Helen Hawken, Jerry Kler, Ted Streshinsky, and Anne Wertheim for their careful reading of the manuscript and their many invaluable comments and suggestions. Most of the line drawings were prepared by Judy Williamson. Others were prepared by the author. All photographic illustrations were done by the author with a 35mm single-lens reflex camera. A special vote of thanks is due Judy Erickson, amanuensis par excellence.

MILL VALLEY, CALIFORNIA
WILLIAM R. HAWKEN

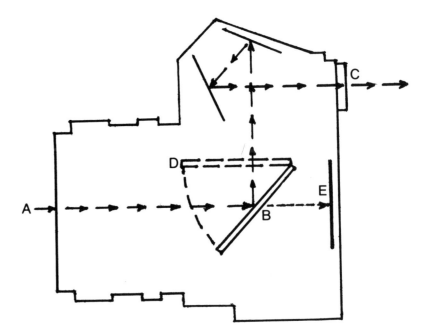

Figure 2. Light entering the lens (A) is reflected by a mirror (B) upward to other mirrors which reflect the image outward through the viewfinder. When a picture is taken, the first mirror (B) moves to position (D) allowing light to reach the film surface (E).

INTRODUCTION

The modern single-lens reflex camera is a highly versatile precision instrument capable of producing excellent quality photographs of almost any kind of subject matter under a wide variety of conditions. Because of their unique capabilities and very high quality performance, many professional photographers rely on single-lens reflex cameras for a good deal of their work. The very same cameras are also owned by thousands of amateur photographers who are not producing excellent quality photographs only because they are not using their cameras beyond a small percentage of their full capability. One wonders how many travelers in this age of low-cost air travel have availed themselves of the low prices in duty-free ports to purchase a high quality single-lens reflex camera. This camera is seldom used because it seems too complicated, or is used only for "snapshooting"—a function that could be performed much more simply and almost as well by a camera costing one-tenth the price.

One of the major reasons why many amateur photographers fail to achieve high quality photographs rests on the misassumption that quality can only be achieved

through complex technical procedures or hard-won esoteric knowledge beyond their grasp. This is not true. Although some remarkable photographs require very complicated techniques and controls and an arsenal of equipment, a great deal of the high quality work done by professionals with single-lens reflex cameras requires no such degree of sophistication. The most important thing a competent professional photographer brings to his work is his *understanding* of his camera; its capabilities and limitations, what it can and cannot do. To learn to understand your camera does not require a technical background or extensive training, as this book will show.

Once you understand just what is going on inside your camera when a photograph is made, how your lens works, and how the various mechanical parts and controls work, a whole new world of photography will be open to you.

Understanding what your camera cannot do is just as important as learning all the remarkable things it can do. Once its limitations are understood, you will not waste time and effort on the impossible and reap a harvest of disappointments.

So let us begin.

One of the very first things to understand is that your camera is a precision instrument. Do *not* begin your acquaintanceship with it by turning and pushing its various levers, buttons, rings, and dials. *Damage could result!* Chapter by chapter you will be gradually introduced to the controls of your camera. Do not experiment with them until you know what they are for, how they function, and how to use them correctly.

The name *single-lens reflex,* which has been given to cameras of a certain design, is partly the product of traditional photographic nomenclature and partly the product of the history of camera design. The word "reflex" is commonly associated with knee jerks, fast muscular responses, or "conditioned reflexes" related to behavioral psychology. In photography the term "reflex" derives from the word "reflection." When applied to a camera it simply means that one or more mirrors are employed to form the image you see when you look into or through the camera.

The term "single-lens" refers to the fact that only one lens is used for both viewing the scene and making a photograph of it.

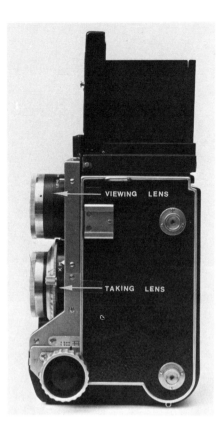

Figure 3. A typical twin-lens reflex camera.

The term "35mm reflex camera" would have sufficed were it not for the fact that the single-lens reflex design was preceded by another design of great popularity that used two lenses—one for viewing the subject and the other for making the photograph. Such a camera is universally known as the "twin-lens reflex" camera. Hence, to distinguish the two types of reflex cameras the qualifying terms "single-lens" or "twin-lens" must be used. The full designation for the type of camera this book will be primarily concerned with is "35mm eye-level single-lens reflex camera."

The film size the camera uses is designated by "35mm." "Eye-level" distinguishes this particular design from another type of single-lens reflex in which one looks down into the camera to view the image instead of through it at eye-level. This latter type is called a "waist-level" reflex camera (although seldom used at waist level!), and was once quite popular, but has largely been supplanted now by the eye-level type.

Figure 4. A "waist level" single-lens reflex camera in use.

Figure 5. An Introduction to Confusion.

"Camera," by the way, is a Latin word that means "room," so you might think of your camera as a "room with a view," but with a view you can constantly change to suit your fancy.

Your first encounter with a single-lens reflex camera might well be one of fascination mixed with fright. It is so beautifully made and so compact, but what an array of letters, numbers, symbols, arrows, pointers, lines, dots, dials, rings, levers, and strange words, with perhaps the word "Japan" (or "Germany" or "Switzerland") being the only intelligible one! Can mastery ever be possible? And, when you open your "owner's manual," one of the first illustrations shows your camera looking like a technological octopus covered with numbered tentacles. These numbers are "identified" in an accompanying table, which is usually a collection of incomprehensible terms and phrases. To learn their meanings and master the seemingly complex and intricate workings of your camera may initially appear to be too formidable an undertaking, but many things look this way at first—for example, learning to drive a car.

Millions of people drive cars, yet learning to drive a car is much more difficult than learning to operate a camera. With a car, as with a camera, you have to learn a new vocabulary (clutch, brake, gearshift, ignition, trans-

15

mission, accelerator, dashboard, and so on). On the dashboard there are usually several dials and gauges with numbers, letters, and symbols that one must learn to read. Finally, one must learn to use both hands and both feet as well as one's head, and become skilled in a variety of coordinated movements. One can be taught to drive a car by the "Do this!" "Don't do that!" method, but a good driver who is also a responsible owner has learned to *understand* his car. Hence he gets the most out of it in terms of performance and economy.

So it is with photography and your camera. Once you have learned to *understand* your camera—what it does and how it does it—and have become practiced in the use of the various controls, you will find yourself using your camera as surely and as effortlessly as you drive a car. A skilled driver drives instinctively. He does not have to think through each new situation. So it is with the skilled photographer. He has learned to use his camera instinctively. After having learned to master more than a ton of steel, glass, and moving parts operating at high speed, don't be intimidated by a two-pound camera merely because it is unfamiliar to you!

A car has essentially one function—to get you from one place to another. It is basically a means of transportation. Cameras are often mistakenly regarded as merely a means for recording. In fact, they are capable of far more than such a limited, utilitarian function.

Used thoughtfully, skillfully, and imaginatively, your camera can become the means for creating photographs of great beauty and expressiveness. So bear in mind that as your understanding of your camera grows, this will lead not merely to technical proficiency but to the mastery of a new medium for creative expression.

I. Understanding Exposure

BASIC CONCEPTS

Photography, first and foremost, is dependent on the action of light, or lighting.

The commonest sources of light used in making photographs are the sun, electric light bulbs that burn steadily, and "flash" illumination that lasts for a fraction of a second. Other sources of light can be and often are used. Many are the photographs that have been made by the light of a candle or the light of the moon.

To be able to see a subject through our eye or photograph it through a camera lens, light rays coming from a light source fall upon the subject and then are reflected from it to the eye or the camera. The subject itself thus becomes a light source.

Photographic materials are composed of substances that respond to the action of light. To make a photograph, the film you load into your camera must be *exposed* to light rays passing through the lens of your camera. How satisfactory your photograph will be will depend in large part on how much exposure to light the film received. Too little—*underexposure*—or too much—*overexposure*—can diminish the quality of your photograph or ruin it completely.

Figure 6. The subject as light source. Light rays illuminating a scene are *reflected* from its various components. It is these reflected light rays emanating from each part of the scene that the eye perceives and the camera records.

17

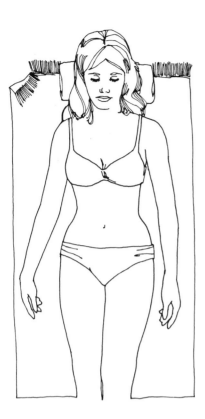
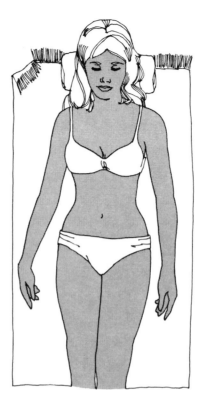

Figure 7. "Underexposure" to "overexposure" in getting a suntan.

Exposure in photography by means of light rays is analogous to getting a sun tan. If you go out into a hot summer sun at midday for two minutes, you will not get a tan. This would be underexposure. But, if you remained in the sun for two hours, the result might be a painful burn. This would be overexposure. Somewhere between these two extremes is the *correct exposure time* for tanning.

To carry this analogy a step further, if you remained out for two hours in the low and weak sun of wintertime, no burning would occur, and perhaps not even any tanning. Getting a sun tan is therefore governed by two factors—*time* and *intensity*. The lower the intensity of the sun's rays, as in wintertime, the longer the time required for tanning, and, under the higher intensity of the sun's rays in summertime, the shorter the time required.

In photography, where we are dealing with the effects of light rays, the same two factors—*time* and *intensity*—are constantly present. With light of a certain degree of brightness being reflected from a scene or object or person you wish to photograph, the two problems you will learn to solve are:

1. How to control the *intensity* of the light reaching the film.

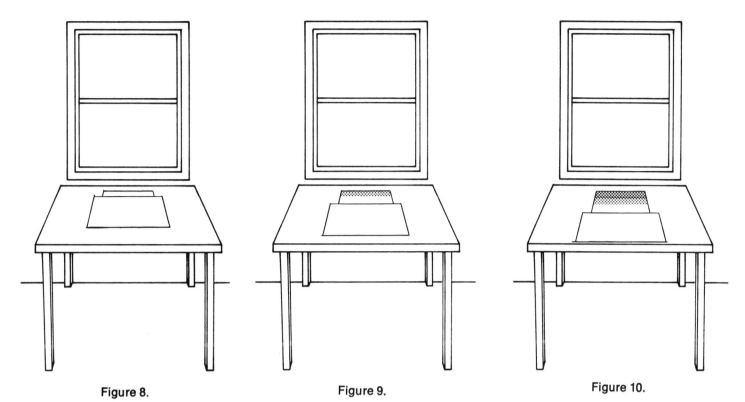

Figure 8.

Figure 9.

Figure 10.

2. How to control the length of *time* the light will be permitted to act on the film.

Two of the most important controls on your camera are provided for the purpose of regulating intensity and time. How these controls work will be described in the next two chapters.

To gain a clearer idea of how exposure works in photography in terms of both time and intensity, let us observe what happens to a sheet of light-sensitive photographic paper when it is exposed to daylight. If we place the sheet on a table near a window and cover all but one-fourth of it with a sheet of cardboard (Fig. 8), in a short time the uncovered portion will turn a noticeable shade of gray, which is caused by the action of light falling upon it. If we now move the cardboard so that half the sheet is exposed to light (Fig. 9), the second portion of the sheet will soon turn gray, while the first portion will continue to turn a still darker gray. If we again move the cardboard to allow three-fourths of the sheet to be exposed to light (Fig. 10), the third portion will gradually turn gray and the first two portions will become increasingly darker. If we remove the cardboard (Fig. 11), there will be four bands ranging from a dark gray for the first portion, which

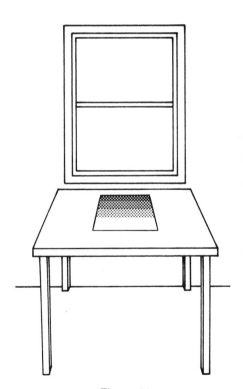

Figure 11.

Figure 12.

Figure 13.

received the longest exposure to light, to a medium gray for the second portion, a light gray for the third portion, and white for the last portion, which received the least exposure to light.

This demonstrates that one factor involved in the action of light on photographic materials is *time*. The longer the time of exposure the greater is the effect.

Now if we place one piece of photographic paper on the table, where light from the window can fall upon it, and another underneath the table, where it will be shielded from the window light, the sheet on the table will gradually turn gray while the sheet underneath the table will show hardly any change at all. Although both sheets of paper were exposed for the same length of time, they were exposed to light of different *intensity*. This demonstrates how intensity operates as the second factor in exposure.

Still another characteristic of photographic materials can be demonstrated using photographic paper and the action of light. To do this we need a simple line drawing on a sheet of translucent paper.

First, place the drawing over a sheet of photographic paper near a lighted window, then cover the two with a piece of glass (Fig. 14). The action of the light from the window will produce a photographic "print." When the line drawing is removed, the tone values of the drawing will have become reversed on the photographic paper. Instead of a dark line against a white background, there is a white line against a dark background. Such a result is called a *negative*. A photographic reproduction in which the values are correct is called a *positive*. We will have more to say on the subject of negatives and positives in the chapter on *Film Types*.

Figure 14.

15. Positive original (left) and negative photoprint (right).

II. Understanding Your Lens

Figure 16.

THE CONTROL OF LIGHT INTENSITY

A useful way to begin to understand how a lens works is to compare it to the human eye, which is infinitely more sophisticated and complex than any lens ever constructed by man. Nonetheless, a camera lens can, in certain ways, far outperform the human eye. While much has been written about the human eye, it will be sufficient for our purpose to consider only two of its functions that have counterparts in a camera lens.

The first has to do with control over the intensity of the light passing through the lens. In the human eye this is accomplished by the *iris*—the colored portion of the eye. The iris has tiny muscles that cause the *pupil*—the black circle in the center of the iris—to increase its diameter when the light is dim, or to decrease its diameter when the light is bright. These muscles in the iris operate rather slowly, as everyone knows from the experience of leaving a sunlit street to enter a dimly lit theater or restaurant. At first one can hardly see anything, but as the iris slowly adjusts one can see more and more.

Camera lenses are equipped with a mechanical counterpart to the iris and pupil called an *iris diaphragm*. This

21

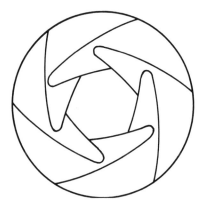

Figure 17. The iris diaphragm of a camera lens.

Iris Diaphragm

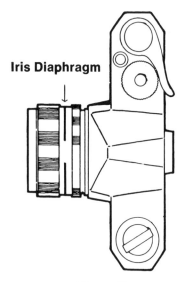

Figure 18.

diaphragm is made up of a number of thin metal plates arranged in a circle so that they overlap each other and are attached to the inside of a ring.

When the ring is rotated in one direction or the other the metal plates move in unison to reduce or to increase the diameter of the circle they form. This circle is called the *aperture* of the lens. This circle thus acts as the "pupil" of the camera lens. Actually, it is not a true circle but only approximately circular. Its shape depends on the number of metal plates used. If, for example, six plates are used, the shape of the aperture will be hexagonal, as shown in Fig. 17. The iris diaphragm is located within the lens barrel.

Because the iris diaphragm of a camera lens is operated mechanically instead of by muscles and nerves, changes in the diameter of the aperture can be made instantly to accommodate extreme differences in light intensity. If a photographer suddenly comes on a scene of great brightness, he can immediately set the iris diaphragm of his camera to a small aperture and make a photograph long before the pupil of his eye has adjusted to the brightness. If, on the other hand, he suddenly enters a situation where the light is very dim, he may have to wait patiently for the iris muscles of his eye to adjust the pupil to a large enough opening before he can even see his subject well enough to photograph it.

The diameter of the aperture of the iris diaphragm is controlled by a ring around the barrel of the lens, which is called the *diaphragm ring* or *lens-aperture ring*. It can be readily identified by its special series of numbers, which will include the following ones but may have others as well: 4, 5.6; 8, 11, 16 (Fig. 19).

At this point mention should be made of the fact that the direction of rotation of the lens aperture ring will be clockwise on some single-lens reflex cameras and counterclockwise on others. This is also true of other rotating camera and lens controls.

Figure 19.

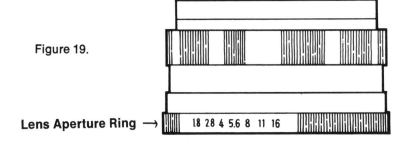

Lens Aperture Ring → | 18 28 4 5.6 8 11 16

III. Understanding Your Shutter

THE CONTROL OF TIME

With *intensity* under control by means of the iris diaphragm, the next consideration is the means for controlling the duration of the *time* interval during which light will be permitted to act on the film. This is accomplished by means of a mechanical device called a *shutter*.

Basically, a shutter is an opaque barrier or curtain whose function it is to "shut out" light. When it is opened the light rays enter the lens and act on the film to make a photograph. The shutter mechanism is positioned at some point between the lens and the film.

A shutter is operated by means of a spring that causes it to open instantaneously, to remain open for a preset interval, and then to close instantaneously. You can simulate the action of a shutter by closing your eyes and then opening them and closing them as quickly as possible.

Although the eyelid and the shutter have often been compared, the analogy is really not valid. The eyelid remains open most of the time for a continuous visual recording, with only momentary closures when we blink. A camera shutter, on the other hand, remains closed except for the interval when a picture is being made. Also,

a camera shutter is designed to open and close for very small, very accurate, and very consistent time intervals. The fixed time intervals at which the shutter of a typical single-lens reflex camera operates usually range from one full second to 1/1,000 sec. with nine other fractional parts of a second between these two limits. A few shutters may have even longer or shorter intervals than these.

Thus, *shutter speeds,* as they are called, provide the control over the *time* interval during which light will be permitted to act on the film.

Camera shutter mechanisms are of two main types. The first and oldest type is called a *leaf shutter* because it is made up of a number of overlapping metal leaves arranged in a circle. When actuated, this type of shutter opens outward from the center of the circle to its edges and then closes back to the center again.

Figure 20. The method of operation of a leaf shutter.

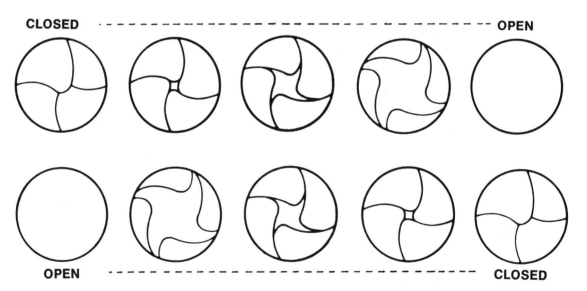

CLOSED - OPEN

OPEN - CLOSED

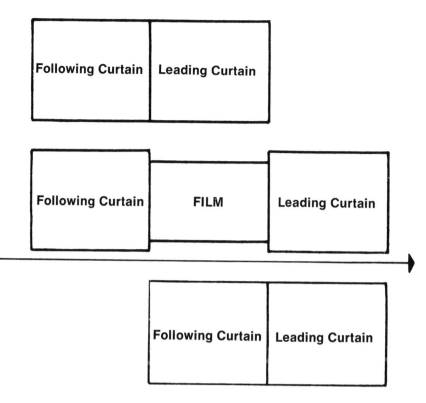

Figure 21. The method of operation of a focal plane shutter.

The second type of shutter is called a *focal-plane shutter,* which consists of a pair of curtains usually arranged to move horizontally. In some cameras, however, they move vertically. When an exposure is made, the leading curtain of the pair moves, say, to the right, uncovering the film so light can act upon it. At the end of the exposure interval the following curtain moves to the right to cover the film surface once again. Almost all single-lens reflex cameras have focal-plane shutters.

In a typical single-lens reflex camera equipped with a focal-plane shutter, the location and relationship of the camera parts we have discussed thus far are illustrated in the accompanying schematic diagram.

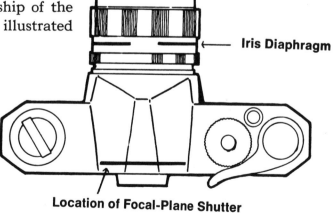

Figure 22. The location of the iris diaphragm and the focal-plane shutter.

THE HALVING AND DOUBLING PRINCIPLE

Let us suppose that you are in a room that has a single window 24 inches high. Above the window is an opaque shade on a roller that can be drawn down any desired amount. "Setting No. 1" is when the window shade is in a fully raised position.

We then draw the shade down 12 inches, or half way, and make a mark on the window frame. This will be called "setting No. 2." Next, we draw the shade down an additional 6 inches, so that 18 inches of the window is covered, and make another mark for "setting No. 3." Then we draw the shade down 3 inches more and mark "setting No. 4." Finally, we draw the shade down 1½ inches more for "setting No. 5."

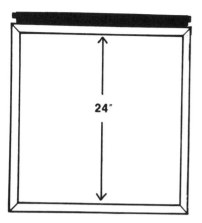

Figure 23. "Setting No. 1"

Figure 24. "Setting No. 2"

Figure 25. "Setting No. 3"

Figure 26. "Setting No. 4"

Figure 27. "Setting No. 5"

As the figures show, we have done the following:

1. At setting No. 1, the maximum amount of light is entering the room (Fig. 28).

Figure 28.

2. At setting No. 2, we have *halved* the amount of light entering at setting No. 1 (Fig. 29).

Figure 29.

3. At setting No. 3, we have *halved* the amount of light entering at setting No. 2 (Fig. 30).

Figure 30.

Figure 31.

4. At setting No. 4, we have *halved* the amount of light entering at setting No. 3 (Fig. 31).

5. At setting No. 5, we have *halved* the amount of light entering at setting No. 4 (Fig. 32).

Figure 32.

If we reverse the process the opposite will occur:

1. At setting No. 4, we have *doubled* the amount of light entering at setting No. 5.

2. At setting No. 3, we have *doubled* the amount of light entering at setting No. 4.

3. At setting No. 2, we have *doubled* the amount of light entering at setting No. 3.

4. At setting No. 1, we have *doubled* the amount of light entering at setting No. 2.

This simple principle of halving and doubling is important because it is the principle underlying two of the most important controls of your camera—the iris diaphragm and the shutter.

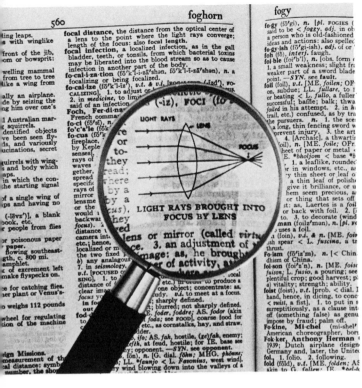

Figure 33. The use of a simple lens to form an enlarged "in focus" image.

BASIC CONCEPTS

"Focus" is a word you are familiar with in other contexts such as "to focus your attention." To focus your attention means to concentrate on something, to bring all aspects of your attention to bear on something whether it be an object that you can see or an abstract idea. To focus a lens means to concentrate light rays on one particular surface, which, in a camera, is the surface of the film. It is of interest to note that "focus" is a Latin word which means "fireplace" or "hearth." Possibly it was adopted for other uses such as with lenses because a fireplace in a darkened room is the point where one's visual attention readily becomes focused. The point where one's visual attention becomes focused is called a *focal point*.

We can use an ordinary magnifying glass to experiment with focus. With such a glass, which is a simple lens, you will have to move the glass alternately nearer to or farther from the object you are examining, in relation to your eye, to find *the correct distance* at which the object can be seen most clearly. At shorter or longer distances the object appears to be fuzzy and indistinct and is said

30

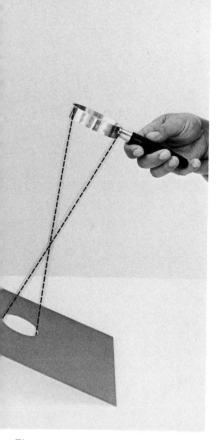

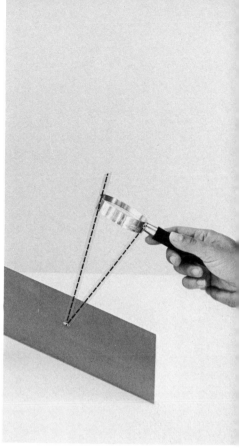

Figure 34. Out-of-focus image: lens-to-surface distance too long.

Figure 35. Out-of-focus image: lens-to-surface distance too short.

Figure 36. Image in focus.

to be "out of focus." At the distance where it is seen most clearly, the subject is said to be "in focus."

The magnifying glass used as a "burning glass" also demonstrates the difference between "in focus" and "out of focus." Interpose a magnifying glass between a piece of paper and the sun and alter the distance between the magnifying glass and the paper. Note that the image of the sun formed on the paper begins as a diffuse circle that becomes smaller and smaller as the distance is shortened until a point is reached where decreasing the distance any further causes the circle to become increasingly larger.

At the correct distance, which is the point where the circle is at its smallest, the sun's rays are *concentrated*— that is, they have been brought into *convergence*—in a very small area. At that particular distance between the magnifying glass and the paper, the rays of the sun are "in focus." At any other shorter or longer distance, the rays would be "out of focus." When in focus, the convergence of the sun's rays into a small circle is so intense that the paper may first start to smoke and then to ignite.

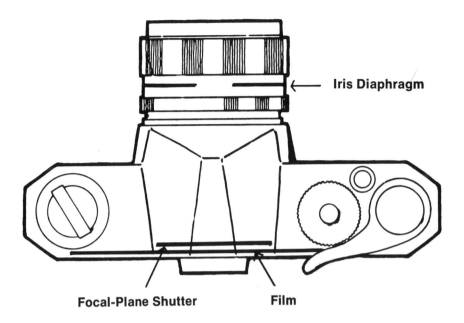

Iris Diaphragm

Focal-Plane Shutter Film

Figure 37. Location of iris dia-
phragm, film, and focal plane
shutter.

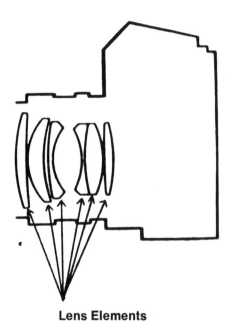

Lens Elements

Figure 38. The several "elements"
of a typical SLR lens.

The same general scheme of things occurs in focusing a camera lens. A certain distance between lens and film has to be established at which light rays from the subject will be brought into convergence on the surface of the film. Unlike the magnifying glass, which uses the lens to form an image of a single light source—the sun—to create a miniature sun on a piece of paper, a camera lens produces miniature images made up of all of the many light rays reflected from all of the objects and surfaces that make up the scene it is viewing.

The surface or plane on which light rays, passing through a lens, converge to form a clear image is called the *focal plane*. In a camera, the focal plane is the surface of the film. It is on this plane that light rays must converge if a sharp photograph is to be obtained. The *focal-plane shutter* described in Chapter III gets its name simply from the fact that its curtain mechanism lies in close proximity to the focal plane, *i.e.*, the film surface.

The lens of your camera is far more complex in its design than a magnifying glass lens. It is made up of a number of individual lenses of different shapes, each of which contributes something to the lens' performance. These individual lenses are called "elements" (Fig. 38).

32

Figure 39. Removing the lens cap.

The front surface of your lens should be protected by a metal (or rubber) "lens cap." Carefully remove it, making certain not to touch (not ever!) the glass surface of the lens itself, or to allow anything else to touch it. By looking through the eyepiece of the viewfinder, you can now begin to see a "camera eye" view of the world.

FROM HERE TO INFINITY

In the preceding section we discussed the importance of establishing the correct distance between the lens and the focal plane to achieve an "in focus" or sharp image. The next step will be to explore another factor—the distance between the lens and the subject to be photographed. Once again let us turn to the human eye to make things clearer.

If you look at a nearby object, it will appear sharp and clear and will be in focus. If you now look at a distant object it, too, will be clear and in focus. But there is something going on here of which we are not conscious.

33

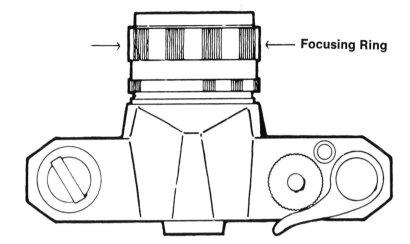

Focusing Ring

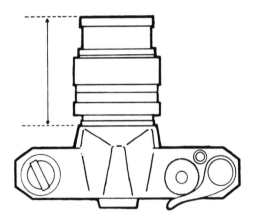

Figure 40. Location of the focusing ring.

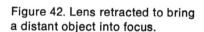

Figure 41. Lens extended to bring a nearby object into focus.

Figure 42. Lens retracted to bring a distant object into focus.

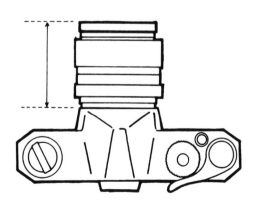

The behavior of light rays passing through a lens, whether the lens be the human eye or the lens of a camera, is such that rays from a nearby object and rays from a distant object do not come into focus on the same plane. You can readily observe this by looking at an "in focus" object a long distance away through the viewfinder of your camera and then looking at an object only two feet from the camera.

To bring nearby objects into focus, the distance between the lens and the film (the focal plane) must be *greater* than it is when the lens is focused on a distant object. The nearer the object, the greater this distance must be. Therefore, to bring near objects into sharp focus you must *increase* the distance between the lens and the film. In the human eye the needed change in distance occurs instantaneously and automatically through muscle action as we shift our vision from distant objects to near objects. In single-lens reflex cameras this change is accomplished by means of the *focusing ring* on the lens barrel.

The focusing ring is a large knurled ring that operates on a type of screw-thread mechanism. As you turn it, notice that the lens moves in or out. The closer an object is to the camera the more you will have to turn the focusing ring in one direction to increase the lens-to-film distance to bring the subject into sharp focus. To focus the lens on objects at increasingly greater distances, turn the focusing ring in the opposite direction to shorten the lens-to-film distance until you cannot turn the focusing ring any farther. At this stopping point you will notice that all distant objects are in focus, whether they are 50 or 500 yards away, or five miles away.

34

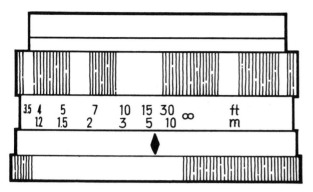

Figure 43. Distance scale in feet (f) and meters (m). Pointer indicates distance on which lens is focused.

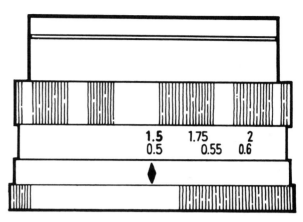

Figure 44. The minimum distance on which a given lens can be focused as shown on the distance scale.

This point, where all objects beyond a certain distance are in focus, regardless of differences in their distances, is called *infinity focus,* or simply *infinity.*

Alongside of the focusing ring of your camera you will find a pointer or arrow opposite a *distance scale,* which includes two scales of numbers. As you rotate the focusing ring, the numbers in these two scales will move past the pointer. These two scales indicate the distance at which the lens is focusing in *feet* (ft) and in *meters* (m).

Both scales begin with the lens set at infinity. Because no one number can express an infinite distance, a symbol is used very much like the figure "8" turned sideways: "∞." As you rotate the focusing ring the numbers become progressively smaller to indicate closer and closer distances at which the lens is focused. A typical *footage* scale reads, in descending order:

∞ 30 15 10 7 5 4 3.5 3 2.5 2.25 2 1.75

A typical *metric* scale reads, in descending order:

∞ 10 5 3 2 1.5 1.2 1.0 0.9 0.8 0.7 0.65 0.6 0.55 0.5

The lens shown in the accompanying figure cannot be focused closer than 1½ feet or 0.5 meters.

When your lens is set at infinity (∞) the lens-to-film distance is at the shortest distance necessary to bring the most distant objects into focus. This particular minimum distance measured from a point within your lens to the film plane defines what is called the *focal length* of the lens.

35

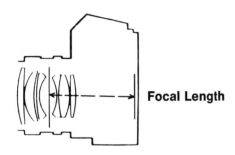

Figure 45. The "focal length" of a lens.

The focal length of a lens for a single-lens reflex camera is stated in the metric system in millimeters, even when the focal length is quite long. For those not used to metric system equivalents to inches, there is a simple rule of thumb that quite closely approximates the relationship between the two: one inch is about 25mm. Hence a focal length of 50mm is about two inches; 75mm, three inches; 100mm, four inches; 150mm, six inches, and so on.

With most single-lens reflex cameras the "standard" (or "normal") lens supplied with the camera usually has a focal length of 50 or 55mm. There are occasional exceptions when a lens slightly shorter or longer than 50mm might be supplied with the camera, for example, 48 or 57mm. These are relatively minor differences that have no great significance in terms of performance characteristics. With lenses in this range of focal lengths any subject more than 100 feet from the camera is, for all practical purposes, at an *infinite* distance even though 100 feet is not a very great distance.

FOCAL LENGTH AND ANGLE OF VIEW

In the preceding chapter the focal length of your lens was defined as the distance from a point within the lens to the film plane when the lens is focused on infinity. The focal length of a lens is an important designation and is prominently marked on the front ring of the lens. (Fig. 46). For cameras of any given type or film size such as those belonging to the 35mm single-lens reflex family, the focal length gives some indication of the approximate angle of view of the lens. The so-called "standard" lens supplied with a 35mm single-lens reflex camera usually has a focal length of 50 or 55mm and has a so-called "normal" angle of view, which is approximately 45 degrees.

One might suppose that a "standard" lens with a "normal" angle of view would approximate the angle of view of the human eye, but this is not the case. Look at a scene with your eye and then view it through the "standard" lens on your camera. You will see immediately that the area the lens takes in is significantly smaller than the area the eye can see. However, since "standard" is the established nomenclature for such lenses, it is the nomenclature we must use.

Figure 46. The focal-length designation on the front of a lens.

Figure 47. Approximate angle of view of a typical "standard" lens.

37

Lenses having focal lengths significantly shorter than that of the standard lens take in a considerably greater angle of view. Lenses of longer focal lengths take in a narrower angle of view (Figs. 48a and b).

Figure 48a. Angle of view of a lens having a focal length shorter than that of a standard lens.

Figure 48b. Angle of view of a lens having a focal length longer than that of a standard lens.

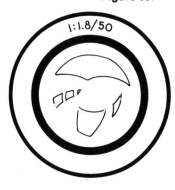

Figure 49.

Figure 50.

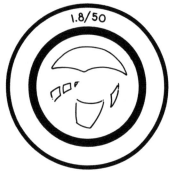

Adjacent to the numbers that state the focal length of a lens there always appears another important number of much lower denomination. This number states, in a kind of mathematical shorthand, the largest aperture setting of the iris diaphragm for that particular lens. This setting is called the *maximum aperture*. It would make things simpler if lens manufacturers would adopt a standard form for stating the maximum aperture and the focal length of lenses but this is not the case. In most instances, the number for the maximum aperture precedes the number for the focal length and the two numbers are separated by a diagonal bar. The simplest form is 1.8/50 (Fig. 49). This signifies a maximum aperture setting of 1.8 and a focal length of 50mm. On many lenses the maximum aperture is expressed as a proportion: 1:1.8/50 (Fig. 50). With other lenses a space is used

38

instead of a diagonal bar, a small "*f*" precedes the focal length, and "mm" is added: 1:1.8 *f*-50mm (Fig. 51).

In addition to these variant forms, which make the situation confusing enough, still another lens uses a small "*f*" *before* the maximum aperture setting: *f*1.8/50mm (Fig. 52). It happens, however, that this use of the small "*f*"—to denote aperture—is *correct* usage. Its use to denote focal length, which is usually denoted by a capital "F," can lead to confusion. This point needs to be stressed because an entire chapter soon to follow will be concerned with *f/numbers* or *lens aperture numbers*, which are universally designated by a small "*f*."

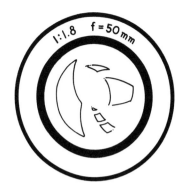

Figure 51.

Figure 52.

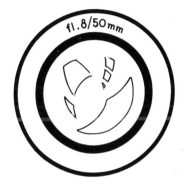

THE AUTOMATIC DIAPHRAGM

You are now familiar with the way the iris diaphragm works to control the diameter of the lens aperture. You also know the location of the diaphragm ring, which, when rotated, changes the diameter of the lens. You may have found, however, that when you rotate the diaphragm ring it does *not* change the diameter. Nothing happens. The lens always stays at its largest opening. This is accomplished by the use of a very clever and useful mechanical improvement of recent years called an *automatic diaphragm*.

Before the invention of the automatic diaphragm a photographer first had to rotate the diaphragm ring to the setting for the largest opening. This permitted the greatest amount of light to pass through the lens for easy composition and critical focusing. When it came to actually taking the picture, however, he had to interrupt the procedure momentarily while he manually turned the diaphragm ring to the required setting. If the required setting was an opening of small diameter, and if he tried to view his subject at that setting, his subject would be quite dim. This would make both composing and focusing very difficult. If, on the other hand, he composed and focused the scene with the lens set at its largest aperture and then

forgot to reset the diaphragm to the smaller opening (and oftentimes even the best of photographers have forgotten), a disastrous degree of overexposure would result. The automatic diaphragm eliminates this problem.

With an automatic diaphragm you can preset the lens for the opening you need for correct exposure. You can then look through your viewfinder, focus, compose, and shoot with the lens always at its largest opening. The moment the shutter release is pressed, but just before the shutter actually opens, the automatic diaphragm closes the diameter of the aperture to the preset opening. When the exposure has been made the diaphragm automatically re-opens to the largest setting (Fig. 53).

 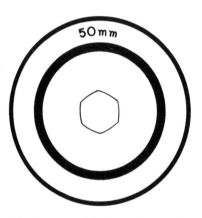

Shutter closed. Iris diaphragm at maximum aperture for viewing and focusing.	Shutter open. Iris diaphragm automatically closes to pre-set aperture for correct exposure.	Shutter closed. Iris diaphragm automatically reopens to maximum aperture.

Figure 53. The action of the automatic diaphragm.

There are times, however, when you will want to view your subject at the lens opening you will be using for making your picture. Therefore, you must be able to disengage the diaphragm mechanism from the "automatic" setting to the "manual" setting. To observe the action of the iris diaphragm as you rotate the diaphragm ring from setting to setting, your lens diaphragm must be set on "manual." You may need to consult your owner's manual or your local camera dealer for the exact location of this control on your camera. On some it will be a sliding switch adjacent to the diaphragm ring; on others it will be a

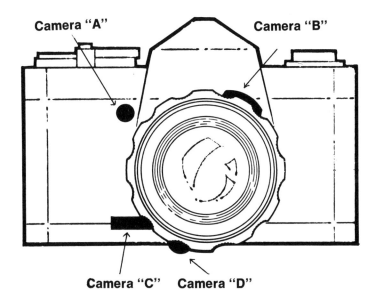

Camera "A" **Camera "B"**

Camera "C" Camera "D"

Figure 54. Some of the various locations of the automatic diaphragm control on different SLR cameras.

knob at the right side of the lens, a small lever underneath the lens, or a button at the left or the right side of the lens (Fig. 54).

Once you have located this control, your explorations of the workings of the iris diaphragm can begin. Compare the brightness and ease in viewing and focusing that the largest aperture offers as opposed to the difficulty of performing the same operations at a very small aperture.

THE MYSTERIOUS "f" NUMBERS

If you will examine the numbers marked on your lens aperture ring you will note that they are usually in the following sequence:

1.8 2.8 4 5.6 8 11 16

These numbers are universally referred to as *f/numbers*. Note that the "*f*" is a small, lower case "*f*"— never a capital. The capital "F" is used to refer to *focal length*—not *aperture*.

Figure 55. Typical lens-aperture markings as shown on lens-aperture ring.

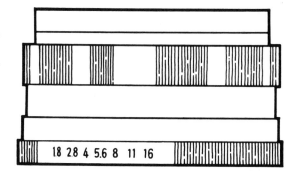

18 2.8 4 5.6 8 11 16

Figure 56. Lens-aperture numbers commonly found on most SLR lenses.

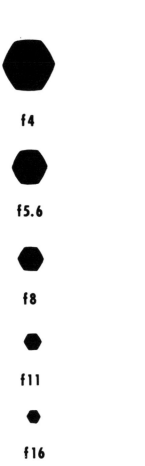

f4

f5.6

f8

f11

f16

Figure 57. The size of the opening of the iris diaphragm at different lens-aperture settings.

Possibly on your lens the first number is not 1.8 but rather 1.4, 1.5, 1.7, 1.9, or perhaps 2. Also, the last number might be 22 instead of 16. These differences can be set aside for the moment. To properly understand the *f/numbers* and what they mean, the series from 4 to 16, which is found on most lenses, will serve as the example.

If, with the automatic diaphragm control in the "manual" position you set the diaphragm ring to 4 and rotate it successively to 5.6, 8, 11 and 16, you will notice that the smaller the aperture becomes the larger is the number associated with it. This may appear to be illogical and confusing. Why should a *large* number be used to signify that the lens is letting in a *small* amount of light and a small number a large amount of light? The answer is that the numbers tell nothing about either the actual diameter of the opening or the actual amount of light entering the lens. What they express is a relationship between two things:

1. The focal length of the lens (Fig. 45).

2. The diameter of the lens opening (aperture) of the iris diaphragm (Fig. 58).

Diameter Opening of Iris Diaphragm

Figure 58. Aperture (diameter of the opening of the iris diaphragm).

If, for example, we have a lens with a focal length of 50mm, and were easily able to measure the diameter of the diaphragm opening when the lens aperture ring is set at 4, we would find that the diameter is 12.5mm. Now here is where the relationship enters. If 12.5mm (the diameter of the aperture) is divided into 50mm (the focal length), it will go an even *four* times:

$$
\begin{array}{r}
4.0 \\
12.5 \overline{\smash{\big)}\, 50.0} \\
\underline{50.0} \\
0
\end{array}
$$

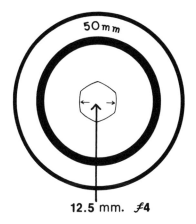

12.5 mm. *f*4

Figure 59. At an aperture setting of *f*/4, the diameter of the opening of the iris diaphragm of a 50mm lens measures 12.5mm.

The "4" setting on your aperture ring thus tells you that at that setting the focal length of your lens is *four* times the diameter of the aperture, or, conversely, the diameter of the aperture is one-*fourth* the focal length.

At 5.6 the diameter of the aperture is 8.93mm. When it is divided into the 50mm focal length, it goes 5.6 times. At this setting the diameter of the aperture is 1/*5.6th* of the focal length. The same arithmetical relationship holds true for the rest of the settings. At a setting of "8" the diameter of the aperture is one-*eighth* the focal length. At "11" it is one-*eleventh* the focal length and at "16" it is one-*sixteenth*.

Lenses are marked with numbers that express the *relationship* between the diameter of the aperture and the focal length of the lens. This relationship is constant for all lenses regardless of their focal length. Suppose, for example, a photographer is using a 50mm focal length lens under conditions that require an aperture setting of *f*/8. Then, for some reason, he decides to change to a 200mm focal length lens. The photographer need only set the aperture ring of the 200mm lens at *f*/8 to achieve the same exposure he had with the 50mm lens. If a different system of markings were used, every lens of a different focal length would have a different set of numbers and this would create a very complicated situation indeed.

The next question to consider is the *inter*relationship of *f*/numbers. Why those particular numbers? Why *f*/5.6 instead of 5.5 or 5.7? This will be the subject of the chapter that follows.

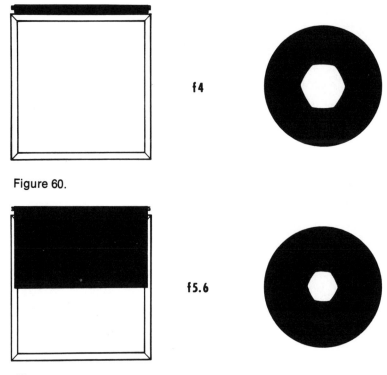

Figure 60.

Figure 61.

THE HALVING AND DOUBLING PRINCIPLE REVISITED

To explain the interrelationships between the f/numbers, we can return to the window with its shade and the halving and doubling principle.

When the diameter of the aperture of the iris diaphragm of a lens is 1/5.6th (f/5.6) the focal length, exactly one *half* as much light is entering as when the aperture is 1/*4th* (f/4) the focal length. We can let the window with its shade fully raised correspond to a setting of f/4 (Fig. 60). When the shade is drawn half way down this would correspond to an aperture of f/5.6 (Fig. 61). *Halving* the amount of light once again by drawing the shade farther down corresponds to an aperture of f/8 (Fig. 62). *Halving* it still again brings us to f/11 (Fig. 63), and with one more *halving to* f/16 (Fig. 64).

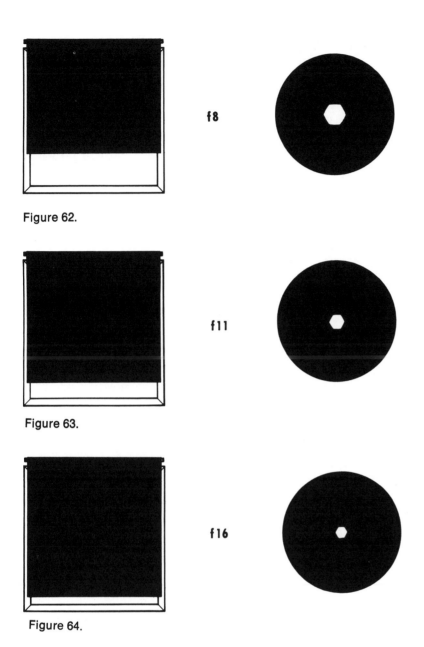

f 8

Figure 62.

f 11

Figure 63.

f 16

Figure 64.

Reversing the process and raising the shade so that we *double* the amount of light entering each time corresponds to the steps of increasing the diameter of the aperture from 1/16*th* the focal length, to 1/11*th*, *to* 1/8*th*, to 1/5.6*th*, and finally to 1/4*th*. Each successive larger opening *doubles* the amount of light entering the lens.

We can now apply what we have learned about the interrelationship between other *f*/numbers larger or smaller than the five that lie between *f*/4 and *f*/16. A simple table will serve the purpose.

<div align="center">

f/number

</div>

Passes twice as much light as:		Passes half as much light as:
f/2	*f*/1.4	
f/2.8	*f*/2	*f*/1.4
f/4	*f*/2.8	*f*/2
f/5.6	*f*/4	*f*/2.8
f/8	*f*/5.6	*f*/4
f/11	*f*/8	*f*/5.6
f/16	*f*/11	*f*/8
f/22	*f*/16	*f*/11
f/32	*f*/22	*f*/16

There is one *f*/number quite often found on lenses that does not fit the halving and doubling table quite so neatly. This is *f*/3.5, which is often the maximum aperture of wide-angle lenses. At an *f*/3.5 setting approximately one-third more light is entering a lens than the next smaller setting of *f*/4, and approximately two-thirds less light than the next larger setting of *f*/2.8.

In addition there are other minor variations, particularly in maximum lens apertures, such as *f*/1.5, *f*/1.7, *f*/1.8, and *f*/1.9. The amount of light that enters the lens at these settings can be estimated depending on whether they fall closer to *f*/1.4 or to *f*/2.

VII. Understanding Jargon

AN INTRODUCTION TO
THE LANGUAGE

Since you will be reading other books and articles about photography, you are bound to encounter many new words, including slang and jargon that you don't understand. So, it is time to "learn the language" so to speak.

When you were looking for the focal length and maximum aperture numbers on the front of your lens you probably noticed a strange word of two or three syllables ending in either "r" or "n" and wondered what it meant. A typical example would be the word "Tessar." At one time "Tessar" on a lens meant that the lens was based on a highly successful lens formula designed by Dr. Paul Rudolph for the Zeiss Optical Works in Jena, Germany. Today their signification is, for the most part, nothing more than the manufacturer's trade name. Just as "Mustang" or "Thunderbird" or "Pinto" signify products of the Ford Motor Company, so do the words on lenses identify the lens as being the product of a particular camera manufacturer. If you put a lot of them together you have the makings of an amusing song of the "tongue twister" type

Figure 65. A few of many well-known lens names.

which can be sung to the music of *"I Am the Very Model of a Modern Major General"* from the operetta, "The Pirates of Penzance" by Gilbert and Sullivan. Try it.

> There's Summicron and Hexanon and Fujinon and Noritar
> And Rikenon and Yashinon and Biogon and Technikar
> And Topcor Nikkor Rokkor Planar Tessar Summar Elmar Dagor Ektar Switar Soligor and Super-Macro-Takumar.
> There's Angulon and Componon and Summaron and Vivitar
> And Xenar Symmar Ultron Sonnar Biotar and Componar
> There's Xenon Hektor Raptar Artar Optar Protar Camron Caltar Curtagon and Elmarit and Hologon and Summitar.

With that we will dispense with any further concern with the names on lenses.

There is, however, another kind of photographic language that is the informal jargon, the "street language" of photography. This is what you hear professionals or advanced amateur photographers using when they "talk shop." The vocabulary of this language is also widely used by writers of photographic subjects. Like many cant languages it is dotted with redundancies, abbreviations ("SLR" for single-lens reflex), and slang ("shoot" a picture, out "shooting," the next "shot," and so on).

Up to this point, in order to avoid confusing you, I have striven to refer to parts of your camera by rather long and formal terms that are more fully descriptive, and to use them consistently to the exclusion of other terms. For example, I have repeatedly mentioned the "opening of the iris diaphragm" or even "the diameter of the opening of the iris diaphragm." Both phrases are long and cumbersome. Let's see how they translate into photographic jargon.

Long ago, before the iris diaphragm was invented, the size of the lens opening was regulated by thin strips of metal. Each strip had a different size hole corresponding to the markings discussed in the last chapter, *i.e.*, 4, 5.6, 8, 11, 16, and so on. When an exposure was to be made, the photographer selected the piece of metal with the appropriate size hole and inserted it into a slot in the top of the lens mounting. Because these metal devices were used to "stop" a portion of the light from reaching the film, they became known as *stops*.

Although this term is no longer appropriate, the "diameters of the different openings of the iris diaphragm" are still universally referred to as *stops*.

A very common variant on this nomenclature that is also widely used derives from the common photographic shorthand of referring to the focal length of a lens by a capital "*F*" and the various lens openings with a small "*f*." Lens openings are therefore commonly referred to as *f/stops* and, to distinguish them from other uses of the same number, are written with the small "*f*" preceding them:

$$f/1.4, f/2, f/2.8, f/4, f/5.6, f/8, f/11, f/16$$

Still another trend in the use of photo jargon has been simply the use of a common English word rather than a cant phrase like "*f*/stop," and often more than one English word such as "aperture," "opening," or "setting."

This multiplicity of terms, which all refer to the same thing, brings to mind a comic strip dialogue between a little boy and a somewhat older little girl with a larger vocabulary.

Girl: It's almost time for tiffin.
Boy: For *who?*
Girl: Not *who—what!*
Boy: Not who what *what?*
Girl: Tiffin is another word for *lunch!*
Boy: Who *needs* another word?
Girl: Lots of words mean the same thing.
Boy: Then why don't they get rid of them!

You will sympathize with the little boy's point of view when you have to cope with this unnecessary variety of photographic terms. For instance, if I want you to tell me how to set the iris diaphragm of a camera for a particular picture, my question might take any of the following forms:

1. What stop...?
2. What *f*/stop...?
3. What *f*/number...?
4. When lens opening...?
5. What opening...?
6. What lens aperture...?
7. What aperture...?
8. What aperture setting...?
9. What diaphragm opening...?
10. What diaphragm setting...?

If I think the aperture setting (or *f*/stop, or opening, or whatever!) is too large I may say to you:

1. Stop *down*... (*down* meaning "smaller")
2. Close down...
3. Use a smaller stop...
4. Use a smaller aperture...
5. Use a smaller opening...
6. Use a smaller setting...

If I think you should use a larger aperture setting I might say:

1. Open *up*... (*up* meaning "larger")
2. Use a larger stop...
3. Use a larger *f*/stop...
4. Use a larger opening...
5. Use a larger aperture...
6. Use a larger setting...

If I think you should use the largest possible aperture setting I might say:

1. Use maximum aperture...
2. Use full aperture...
3. Use your lens wide open...
4. Open up all the way...
5. Use your largest *f*/stop...
6. Use your largest opening...
7. Use your largest setting...
8. Use your largest aperture...

Now by this time you will have noticed the same words keep appearing, the commonest of which are: stop, *f*/stop, aperture, opening, and setting. It's too bad we can't *get rid* of four of them! You will at least know now when you encounter them that they do not refer to five different things but simply to the same thing. I will also give you this added reassurance: no other part of your camera is surrounded by such a thicket of redundant terms. Nomenclature in other areas is much simpler.

SHUTTER SPEEDS AND THE HALVING AND DOUBLING PRINCIPLE

The concept of *speed* occurs in several contexts in photography. Lenses having a large maximum aperture are called "fast" lenses because their large aperture makes it possible to take photographs at very short exposure intervals or under very dim light conditions. The maximum aperture denotes what is referred to as the "speed" of the lens.

Question: How fast is your lens?

Answer: $f/1.8$.

Different films have differing degrees of sensitivity in their response to light. Hence they are classified according to their speed from slow to fast, or even "high speed."

A third area where the use of the term "speed" is more closely related to our ordinary usage is in connection with the action of the camera shutter. If you will examine a camera, you will find a series of numbers (usually a dial but sometimes on a ring around the lens barrel) which reads as follows:

1, 2, 4, 8, 15, 30, 60, 125, 250, 500, 1000.

In addition, the letter "B" and sometimes the letter "T" will appear on the dial. Let us first consider the numbers.

Figure 66. Typical shutter-speed dial markings.

All of these numbers are abbreviated expressions for *fractions* of a second and denote *shutter speeds*. Fully stated, they read as follows:

1 = 1 Sec.	60 = 1/60 Sec.
2 = 1/2 Sec.	125 = 1/125 Sec.
4 = 1/4 Sec.	250 = 1/250 Sec.
8 = 1/8 Sec.	500 = 1/500 Sec.
15 = 1/15 Sec.	1000 = 1/1000 Sec.
30 = 1/30 Sec.	

If you open the back of your camera (empty, of course!), you can observe the action of your shutter at different speeds. First, set your shutter-speed dial to "1" (one full second). Cock the shutter slowly and watch the movement of the shutter curtain. Then press the release button and watch the action of the shutter as it instantly opens, remains open for one second, and then instantly closes. Now set the shutter-speed dial to "2" (one-half second), cock it and release it, and then to "4," "8," and so on throughout the scale.

When you do this, be sure to do it indoors in a dry, clean environment at a normal temperature so that no dust, lint, moisture, or condensation can enter the camera body while the back is open. Close the camera promptly when you have finished.

You will notice as we go down the list that each successive fraction is *half* the duration of the preceding one, give or take a little to keep the numbers even: 1/8 is half of 1/4; 1/60 is half of 1/30; and so on. Going *up* the list, each successive interval has twice or *double* the duration of its predecessor: 1/4 is equivalent to two-eighths; 1/30 is the equivalent to two-sixtieths; and so on.

Thus the two essential controls you have over exposure—control over light *intensity* by means of the iris diaphragm settings, and control over *time* by means of the shutter speed settings—both work on the *halving* and *doubling* principle. This provides you with a powerful and convenient control system for meeting the requirements of a broad variety of lighting conditions and subject matter. For example, under certain bright lighting conditions you may choose from the combinations of lens-aperture and shutter-speed settings shown in the accompanying diagram.

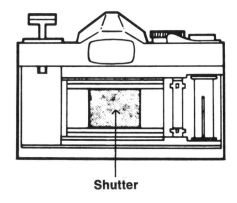

Figure 67. 35mm SLR camera with back open.

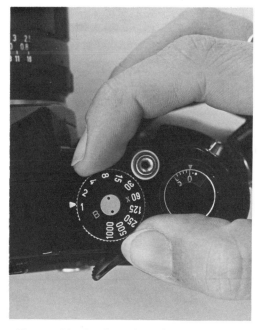

Figure 68. Setting the shutter-speed dial for a one-second exposure interval.

53

Figure 69. Cocking the shutter.

Figure 70. Shutter open.

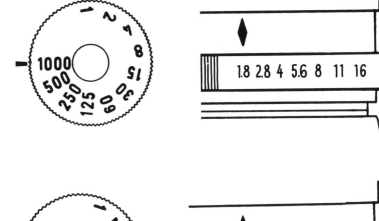

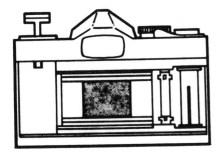

Figure 71. Shutter closed.

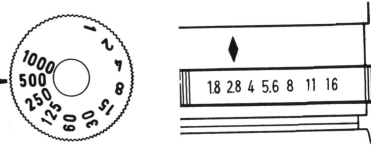

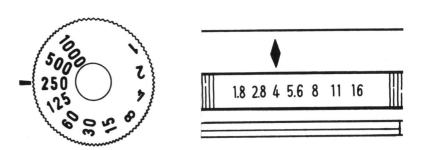

Each of these pairings will yield the same result in terms of exposure because each halving or doubling of light intensity is accompanied by a corresponding doubling or halving of the time interval, and vice versa.

A photographer will decide which combination to use depending upon his subject matter and the lighting conditions, and, in particular, the kind of result he wants in his photograph. While the exposures would all be the same, the resulting photographs can be very different indeed. The nature of these differences will be described in chapters to come.

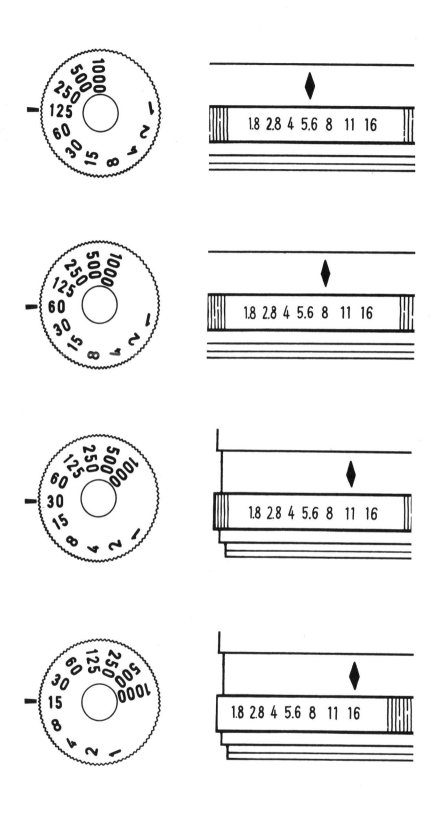

Figure 72. Various combinations of shutter-speed settings and lens-aperture settings that will yield the same amount of exposure.

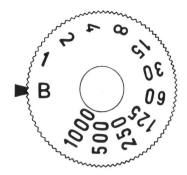

Figure 73. The "Bulb" setting (B).

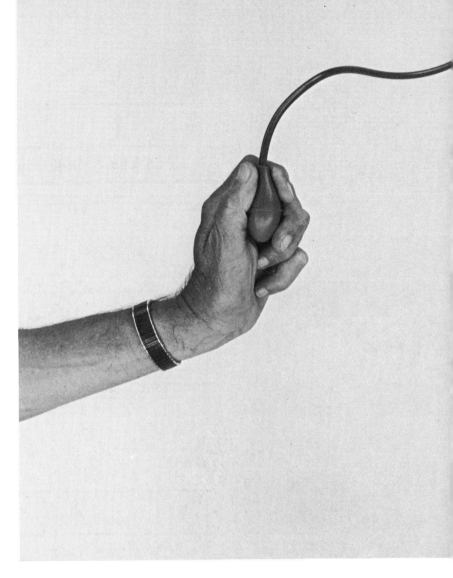

Figure 74. The old-fashioned "Bulb" used to actuate a shutter.

Let us turn now to the letters "B" and "T." The letter "B" stands for "bulb"—a word that goes far back into camera history. It derives from the use of a rubber bulb on the end of a length of rubber tubing that actuated a pneumatic (air-driven) shutter. To make an exposure the photographer had to squeeze the bulb, which opened the shutter. The shutter would remain open as long as the bulb was squeezed, and would close when pressure on the bulb was relieved. Although pneumatic shutters have long since disappeared, the "B" for "bulb" has been retained as the marking for a shutter setting at which the shutter can be held open for a desired time interval. If you open the back of your camera and set the shutter speed dial to "B," you can see how this works. Cock the shutter and press the shutter-release button down and hold it down. The shutter will remain open as long as the shutter-release button is held down. Release it and the shutter will close.

If you have a "T" setting on your shutter-speed dial, the "T" stands for "time." Like the "bulb" setting, the "time" setting is for making exposures longer than provided for in the regular settings of the shutter-speed dial. It differs from the bulb setting only in that the shutter release does not have to be held down while making an exposure. Cocking the shutter and pressing the shutter-release button causes the shutter to open. It will remain open until the shutter-release button is pressed a second time to close it.

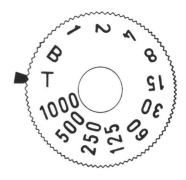

Figure 75. The "Time" setting (T).

HALF-STOPS

You now know that by changing from one lens-aperture setting to another you can *halve* or *double* the amount of light entering the lens depending upon which direction the diaphragm ring is turned. You know also that by changing the shutter speed to the next faster or next slower setting you can also *halve* or *double* the exposure time. You might ask: Aren't there times when doubling the exposure would be too much of an increase, or halving it too much of a decrease? This is indeed the case.

Shutters operate only at the specific intervals marked on the shutter-speed dial. You cannot, for example, set the shutter-speed dial between 1/4 sec. and 1/8 sec. to obtain an exposure interval of 1/6 sec. You can, however, set your lens aperture between the marked settings to achieve subtler control over exposures.

In-between lens-aperture settings are called *half stops*, and are designated by the use of a pair of numbers between which they fall. This setting can be designated as "between *f*/8-11."

Figure 76. "Half-stop" setting between *f*/8 and *f*/11.

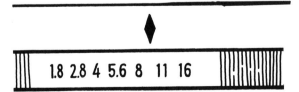

58

If you change from a setting of $f/8$ to a setting midway between $f/8$ and $f/11$, you decrease the amount of light passing through the lens by one-fourth. If, on the other hand, you were to change from a setting of $f/11$ to a setting midway between $f/8$ and $f/11$, you would be increasing the amount of light by one-half.

The design of the mechanism of lens aperture rings varies considerably among different makes. There are three main types:

1. Lenses in which the rotation movement of the ring is smooth and continuous. This type must be set visually by lining up the desired f/stop opposite a pointer or arrow. Selecting a half-stop is also a matter of visually lining up a point midway between any two marked settings opposite the pointer.

2. Lenses in which the rotation movement is not smooth and continuous but instead moves in "clicks" from marked setting to marked setting. These "click stops" as they are called can be felt as you rotate the ring. One advantage they offer is that with a little familiarity it is not necessary to look at the lens aperture scale to set the aperture. One can do this by "feel" by counting the "clicks." Half-stops, however, must be set visually.

3. Some lenses, in addition to click stops for marked settings, also have click stops for the half-stops. Lenses of this design are the easiest and most convenient to use.

There are some lenses (fortunately in the minority) with automatic diaphragms that cannot be set to operate at half-stops. With such lenses you can visually set the lens aperture ring for a half-stop—say between $f/8$ and $f/11$—but when the automatic diaphragm closes, it will close either to $f/8$ or to $f/11$, depending on which is closer to the in-between point where you set it.

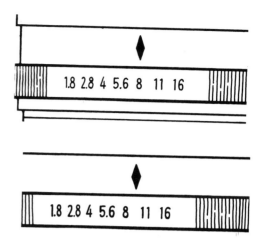

Figure 77. $f/8$ setting and the next *smaller* "half-stop" setting between $f/8$ and $f/11$.

Figure 78. $f/11$ setting and the next *larger* "half-stop" setting between $f/11$ and $f/8$.

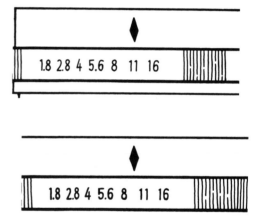

Figure 79. Only a small band in the middle of the photograph is in focus. Both the foreground and the background are markedly out of focus.

Figure 80. In this photograph of the same scene shown in the preceding illustration, all elements from near foreground to distant background are in focus.

X. Understanding Sharpness

AN INTRODUCTION TO DEPTH OF FIELD

Undoubtedly, you have seen photographs in which objects in the near foreground or distant background were noticeably out of focus. You have seen others in which all objects from the near foreground to the far distant background were all sharply defined. The difference between two such photographs is a difference in *depth of field*. "Field" refers to that portion of the photograph in which objects appear sharply defined. "Depth" refers to the extent, from near to far, of this field (Figs. 79, 80).

Lack of knowledge concerning a few simple principles governing depth of field is one of the most common causes of failures and disappointments among newcomers to photography. Therefore, knowing how to control depth of field is of considerable importance for making successful photographs.

To begin our exploration of depth of field, let's experiment with ways of photographing a single subject that extends from a point near the camera position to a point 100 feet or more away. A long fence extending in a straight line will make a suitable subject. The following series of illustrations will introduce variations in the *lens aperture*

and the *distance on which the camera is focused*—to show what effect changes in these settings have on depth of field. These two settings will be studied separately as well as in combination. For the first series of photographs we will focus a camera equipped with a standard 50mm focal length lens on a board in the fence 15 feet away from the camera. If we set the lens aperture to ƒ/5.6 (pairing it of course with a shutter speed appropriate to the light conditions) and make an exposure, the resultant photograph would show that not only is the board 15 feet away from the camera in sharp focus but several other boards nearer and farther than 15 feet are also in sharp focus (Figs. 81, 82).

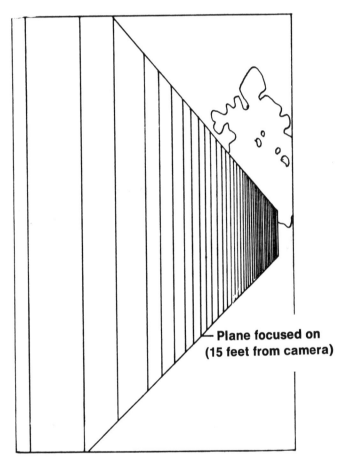

Plane focused on
(15 feet from camera)

Figure 81. Camera with 50mm lens focused on a point 15 feet distant. (Schematic view.)

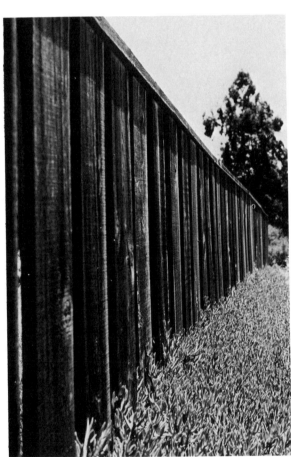

Figure 82. Depth of field at ƒ/5.6 (50mm lens focused at 15 ft.).

Depth of field is therefore a zone whose boundaries lie on either side of the plane on which the camera is focused and within which objects appear sharply defined.

The boundaries are termed the *near plane* and the *far plane*. Objects outside of these boundaries will not appear sharply defined (Fig. 83).

If, with the camera still focused on 15 feet, we make a series of photographs at increasingly greater aperture settings—*f*/4, *f*/2.8, *f*/2, and *f*/1.4—and compare the results with those obtained at *f*/5.6, we will find that there is a considerable change in depth of field (Figs. 84-87).

As the accompanying figures show, *increasing the diameter of the lens aperture causes a decrease in the depth of field.*

If we now make a series of photographs at progres-

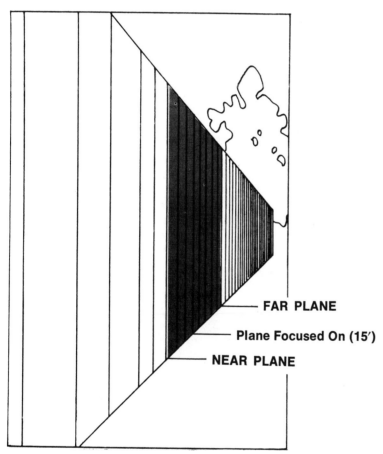

FAR PLANE

Plane Focused On (15′)

NEAR PLANE

Figure 83. Depth-of-field diagram of Figure 82 (*f*/5.6).

sively smaller aperture settings than *f*/5.6—*f*/8, *f*/11, and finally *f*/16—the opposite effect on depth of field will occur. Thus, *decreasing the diameter of the lens aperture causes an increase in the depth of field* (Figs. 88-90).

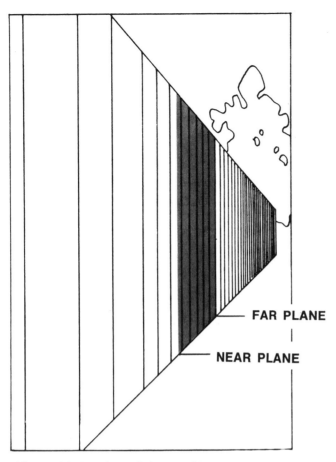

Figure 84. Depth of field at $f/4$ (50mm lens focused at 15 ft.). (Schematic view.)

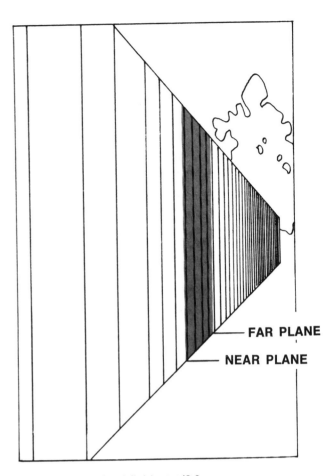

Figure 85. Depth of field at $f/2.8$ (50mm lens focused at 15 ft.). (Schematic view.)

Figure 86. Depth of field at $f/2$ (50mm lens focused at 15 ft.). (Schematic view.)

Figure 87. Depth of field reaches its minimum at $f/1.4$ (50mm lens focused at 15 ft.). (Compare this photo with Figure 90.)

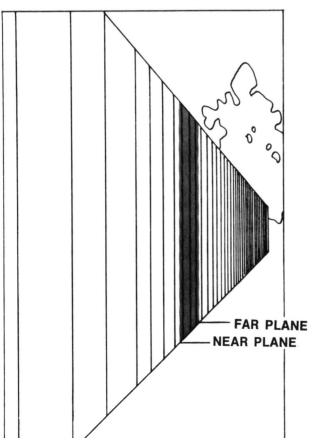

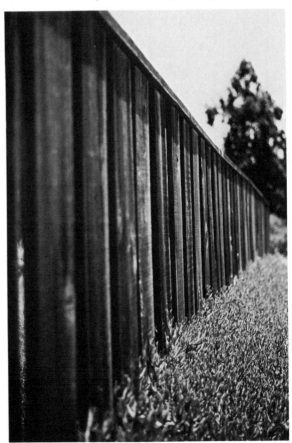

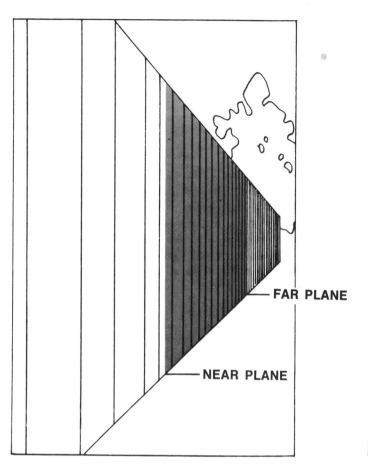

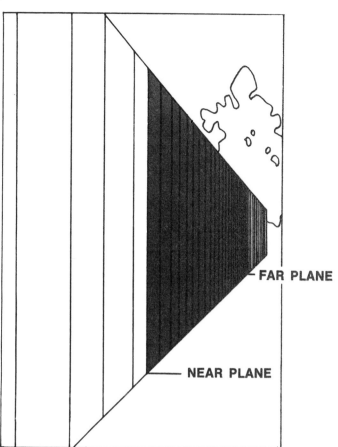

Figure 88. Depth of field at *f*/8 (50mm lens focused at 15 ft.). (Schematic view.)

Figure 89. Depth of field at *f*/11 (50mm lens focused at 15 ft.). (Schematic view.)

Figure 90. Depth of field reaches its maximum at *f*/16 (50mm lens focused at 15 ft.). (Compare this photo with Figure 87.)

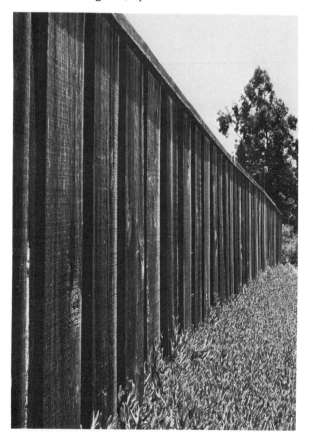

The chart below shows the actual depth of field from near plane to far plane at the different lens apertures.

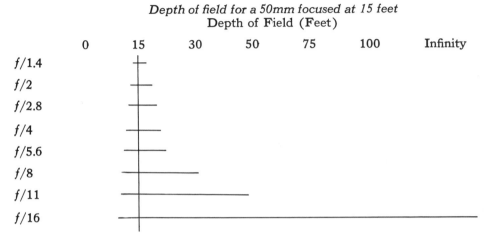

Depth of field for a 50mm focused at 15 feet
Depth of Field (Feet)

From this chart we can observe two other characteristics of depth of field that are important to know and remember:

1. *Depth of field is greater on the far side of the plane on which the camera is focused than on the near side.*

2. *The smaller the diameter of the lens aperture, the greater the increase in depth of field on the far side.*

For the second step in exploring depth of field we will try a different set of conditions. Instead of using one fixed distance and varying the lens aperture setting, we will use one fixed lens aperture setting—*f*/16—and vary the distance on which the camera is focused. To begin with, the camera will be focused at a point only 4 feet from the camera. At a setting of *f*/16, which is the smallest aperture and therefore will provide the maximum in depth of field, depth is quite shallow (Fig. 91).

If we change the distance on which the camera is focused from 4 to 8 feet, a noticeable improvement in the extent of the depth of field is evident. If we carry this a step further and focus the camera on a point 12 feet away, a greater increase in the depth of field occurs (Figs. 92, 93).

If we focus the camera on a point 16 feet away, the far plane extends to infinity (Fig. 94.)

The following chart shows the actual depth of field from near plane to far plane for the different distances on which the camera was focused using a 50mm lens.

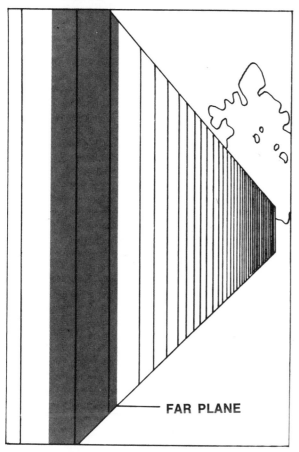

Figure 91. Depth of field of a 50mm lens at a setting of $f/16$ focused at a distance of 4 feet.

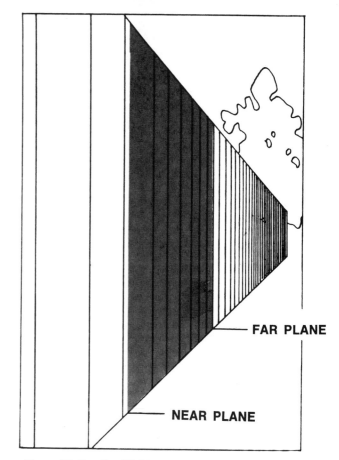

Figure 92. Depth of field of a 50mm lens at a setting of $f/16$ focused at a distance of 8 feet.

Figure 93. Depth of field of a 50mm lens at a setting of $f/16$ focused at a distance of 12 feet.

Figure 94. Depth of field of a 50mm lens at a setting of $f/16$ focused at a distance of 16 feet.

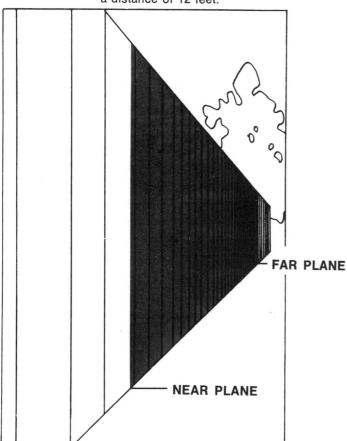

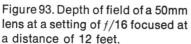

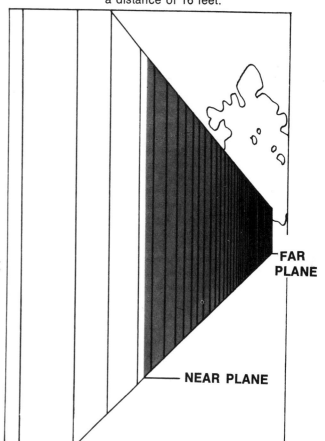

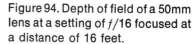

Lens Apertures *f/16*

Depth of Field (Feet)

0 10 20 40 60 80 100

Distance focused on:

4 feet

8 feet

12 feet

16 feet

From the results thus obtained, two additional characteristics of importance concerning depth of field can be observed:

1. *The shorter the distance the camera is focused on, the shallower the depth of field.*

2. *As the distance the camera is focused on is increased, the total depth of field increases until objects at infinity are brought into focus.*

To increase your own familiarity with your camera and depth of field, examine various subjects through your camera lens. Set the automatic diaphragm on "manual" and focus on subjects at different distances. Look through the viewfinder and rotate the lens aperture ring from setting to setting. Observe the increase in depth of field as the lens aperture becomes smaller, or, conversely, how depth of field diminishes as the aperture becomes larger. Because the use of the diaphragm in the "manual" mode allows you to examine the depth of field at different lens apertures, the lever (or switch or button) that controls this is often termed the *depth-of-field-preview lever* (or button or switch).

In addition to varying the lens aperture setting, vary the distance on which the camera is focused. Try focusing your camera on two people, one behind the other, at a distance of four feet. You will find that even at the smallest lens aperture you cannot get a sharp image of both of their faces. Now back off to a distance of 6 feet, then 8 feet, and then 10 feet, and note the increase in depth as you increase the camera-to-subject distance. Try a scene that includes objects both very near and very far from the camera. All such experiments will help you to get a "feel" for the variables involved in depth of field.

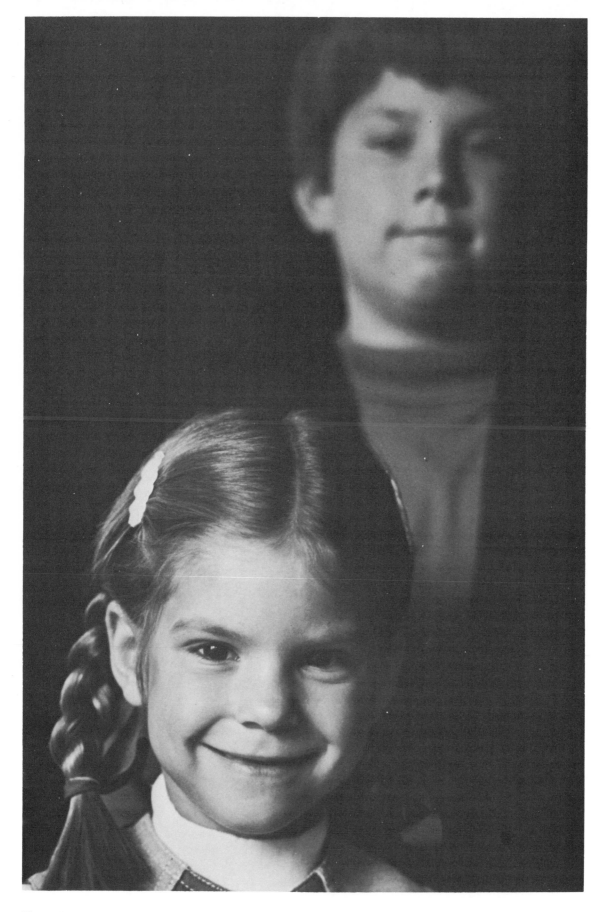

Figure 95. Depth-of-field limitation when working at close range.

There is one further variable affecting depth of field that should be mentioned even though it is not of present concern. This is the focal length of the lens. Depth of field with a lens having a focal length substantially shorter than the standard lens we have used for our experiments would be considerably greater. Conversely, the depth of field of a lens much longer in focal length would be correspondingly more shallow.

We can thus add two more rules concerning depth of field:

1. f/stop for f/stop, the *shorter* the focal length of the lens, the *greater* the depth of field.

2. f/stop for f/stop, the *longer* the focal length of the lens, the *shallower* the depth of field.

These are points to keep in mind if you decide to acquire a wide angle or a telephoto lens.

The main points to remember about depth of field, which apply to all lenses, can be recapitulated as follows:

1. *Increasing the diameter of the lens aperture causes a decrease in the depth of field.*

2. *Decreasing the diameter of the lens aperture causes an increase in the depth of field.*

3. *Depth of field is greater on the far side of the plane on which the camera is focused than on the near side.*

4. *The smaller the diameter of the lens aperture, the greater the increase in depth of field on the far side.*

5. *The shorter the distance the camera is focused on, the shallower the depth of field.*

6. *As the distance on which the camera is focused is increased, the total depth of field increases until objects at infinity are brought into focus.*

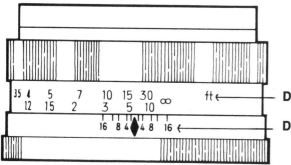

Figure 96. Typical depth-of-field scale.

Distance Scale

Depth-of-Field Scale

BRINGING DEPTH OF FIELD UNDER CONTROL

Now that you have learned the factors that control depth of field, you are ready to use this knowledge effectively to make sharper photographs.

We have found that by looking through the viewfinder of the camera and closing the iris diaphragm down to successively smaller openings, we can "preview" the depth of field. If it is unsatisfactory, we can make changes in the aperture setting or in the camera-to-subject distance. If these measures do not fully succeed, then it may be necessary to "back off" from the subject to increase still farther the camera-to-subject distance in order to increase the depth of field. There is one drawback to the visual "preview" method, however. Closing down the lens aperture reduces the amount of light passing through the lens. Unless the subject matter being examined is very brightly illuminated, details that need to be examined for sharpness may be much too dim to be clearly perceived. Depth of field can be approximated by this method, but it cannot be clearly observed except at fairly large lens aperture settings.

A second method for providing an approximation of depth of field is the *depth-of-field scale* on your camera lens. This scale is located adjacent and parallel to the distance scale. It consists of a series of fine lines extending to the right and left of the central arrow against which focusing distances in feet or meters are read. These lines correspond to the *f*/stop markings of your lens. Their purpose is to indicate the distance of the near and far planes of the depth-of-field zone when your camera is focused at any given distance (Fig. 96).

71

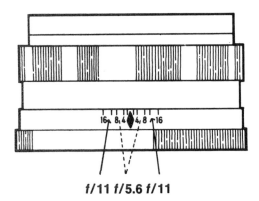

f/11 f/5.6 f/11

Figure 97. Abbreviated depth-of-field scale.

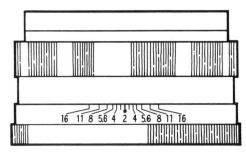

Figure 98. Expanded depth-of-field scale.

Figure 99. Depth-of-field reading at an aperture of f/11 when the camera lens is focused at 15 ft.

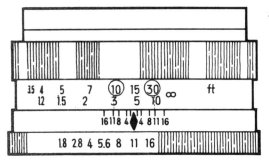

Figure 100. Depth-of-field reading when the camera lens is focused at 3 ft. Even at the smallest aperture (f/16) the total depth of field is less than 1 ft.

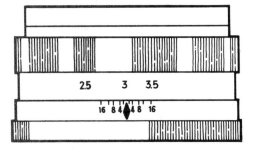

Because of the small space in which the scale must be engraved, some lenses include only a few f/stops. Other lenses include an expanded scale to provide a more complete identification of the lines. One popular single-lens reflex camera has no numbers at all on the depth-of-field scale. Instead, each number on the lens aperture ring is a different color—blue for f/16, yellow for f/11, pink for f/8, white for f/5.6, and green for f/4. The lines on the depth-of-field scale have corresponding colors to identify which line corresponds to which f/stop.

The depth-of-field scale is very easy to use once you understand its operation .With the arrow set at the 15-foot mark on the footage scale, note that the 10- and 30-foot mark are opposite f/11 on either side of the arrow. This tells you that if your lens is focused on an object 15 feet from the camera, everything between 10 and 30 feet will be in the depth-of-field zone. In other words, everything between 10 and 30 feet will be in focus (Fig. 99).

If you attempt to determine the depth of field for any other aperture, however, the problem created by the small space in which the scale must be fitted immediately becomes evident. There is simply no room for a series of footage markings between 10 and 15 feet or between 15 and 30 feet. In this case, one can only approximate the depth of field. At f/8, for example, all you know is that the depth of field ranges from something greater than 10 feet to something less than 30 feet, but the actual range in feet is guesswork.

Although this method is imprecise, even some approximate indication of depth of field is better than none, and at least will prevent gross errors. For example, if you are working with your camera at a distance of 3 feet, a glance at your depth-of-field scale will show that the total depth of field available, even at the smallest lens aperture, is less than one foot. If the total depth of your subject from near

plane to far plane exceeds one foot, you know that you cannot possibly record all of it sharply. If you remember that an increase in the distance focused on will extend depth of field, increasing the camera-to-subject distance to 4 or 5 feet to gain greater depth may solve the problem.

A third method for obtaining depth-of-field data is from the *depth-of-field table* provided by the camera manufacturer for your particular lens. A typical table usually provides very accurate distance figures for the near plane and the far plane for a number of distance settings, but not for all of them. The table might provide depth-of-field zone distances accurate to decimal fractions of an inch for distance settings of 1½, 2, 3, 5, 10, 15, 30 feet and infinity. But, as with the depth-of-field scale on your lens, the depth at any distance not given in the table must be approximated. At a distance setting of 12 feet, for example, the distances of the near and far planes will lie somewhere between the distances given for 10 and 15 feet.

Object Distance	f/2	f/2.8	f/4	f/5.6	f/8	f/11	f/16
∞ (ft)	132' 2" —∞	94' 5-3/4" —∞	66' 2-1/4" —∞	47' 3-7/8" —∞	33' 2-1/8" —∞	24' 2" —∞	16' 8" —∞
30	24' 6-1/4" —38' 6-3/4"	22' 10-3/8" —43' 6-1/2"	20' 9" —54' 4-1/4"	18' 5-3/4" —80' 7-1/2"	15' 10-1/2" —∞	13' 6-1/8" —∞	10' 9-7/8" —∞
15	13' 6-1/4" —16' 10-1/4"	13' 0" —17' 8-3/4"	12' 3-5/8" —19' 2-7/8"	11' 5-3/4" —21' 8-3/8"	10' 5-1/4" —26' 10-3/8"	9' 4-1/2" —38' 3-1/2"	8' 1/4" —125' 10"
10	9' 4" —10' 9-3/8"	9' 1" —11' 1-1/2"	8' 8-7/8" —11' 8-1/4"	8' 3-7/8" —12' 6-1/2"	7' 9-1/4" —14' 7/8"	7' 2-1/8" —16' 7-5/8"	6' 4-3/8" —23' 8"
7	6' 8" —7' 4-3/8"	6' 6-5/8" —7' 6-1/4"	6' 4-1/2" —7' 9-1/4"	6' 1-7/8" —8' 1-1/2"	5' 10-1/4" —8' 8-3/4"	5' 6-1/8" —9' 7-1/2"	5' 3/8" —11' 7-1/2"
5	4' 10" —5' 2-1/8"	4' 9-1/4" —5' 3"	4' 8-1/8" —5' 4-3/8"	4' 6-3/4" —5' 6-3/8"	4' 4-7/8" —5' 9-1/2"	4' 2-5/8" —6' 1-7/8"	3' 11-1/4" —6' 10-7/8"
4	3' 10-3/4" —4' 1-3/8"	3' 10-1/4" —4' 1-7/8"	3' 9-5/8" —4' 2-3/4"	3' 8-5/8" —4' 3-7/8"	3' 7-3/8" —4' 5-3/4"	3' 5-7/8" —4' 8-1/4"	3' 3-5/8" —5' 1-1/8"
3.5	3' 5-1/8" —3' 7"	3' 4-3/4" —3' 7-3/8"	3' 4-1/8" —3' 8"	3' 3-1/2" —3' 8-7/8"	3' 2-1/2" —3' 8-3/4"	3' 1-1/4" —4'	2' 11-5/8" —4' 3-1/2"
3	2' 11-3/8" —3' 3/4"	2' 11-1/8" —3' 1"	2' 10-5/8" —3' 1-3/8"	2' 10-1/4" —3' 2"	2' 9-1/2" —3' 3"	2' 8-5/8" —3' 4-1/4"	2' 7-1/4" —3' 6-1/2"
2.5	2' 5-1/2" —2' 6-1/2"	2' 5-3/8" —2' 6-5/8"	2' 5-1/8" —2' 7"	2' 4-3/4" —2' 7-3/8"	2' 4-1/4" —2' 8"	2' 3-3/4" —2' 8-3/4"	2' 2-3/4" —2' 10-1/4"
2	1' 11-3/4" —2' 1/4"	1' 11-5/8" —2' 3/8"	1' 11-1/2" —2' 1/2"	1' 11-1/4" —2' 3/4"	1' 11" —2' 1-1/8"	1' 10-5/8" —2' 1-5/8"	1' 10" —2' 2-3/8"

Depth-of-field tables are especially helpful when you work at close distances because they provide accurate figures for conditions where the total depth of field is very shallow (Figs. 104, 105).

WHEN NOT TO FOCUS

In the experiment concerning depth of field and camera-to-subject distance, we found that, when using an aperture of $f/16$, we increased the distance focused on from 4 to 16 feet, the depth of field extended to infinity (Fig. 94).

For every lens aperture there is a certain distance on which the camera can be focused where the far plane will be at infinity and the near plane will be at its closest distance to the camera. At such distance settings you have the maximum total depth of field each lens aperture can provide. Such distances are called *hyperfocal distances*. If you focus the camera at a shorter distance, objects at infinity will not be sharp. If you focus at a longer distance, the near plane will be farther away from the camera. Hyperfocal distances are thus very useful in situations where the maximum possible depth of field is required to produce a sharp image of both near and far objects.

The obvious question at this point is: What are these magic distances? Actually you do not need to know them, and even if you did, the scarcity of footage markings on the distance scale of your camera would make it impossible to locate and set them with accuracy. However, there is a very simple way to set your lens for the hyperfocal distance for any particular lens aperture. Just set the infinity symbol on the distance scale opposite the line for the f/stop you are using. The distance of the near plane can then be approximated from the distance scale. For example, with the infinity symbol opposite the $f/16$ line, the depth of field of a lens having a focal length of 55mm extends from approximately 9 feet to infinity.

A typical situation that shows the advantage of using a hyperfocal-distance setting is in photographing a large group of people. Suppose you want to photograph a large outdoor gathering of people who are all at different distances from the camera, including some over 100 feet away. You are using a 50mm lens at an aperture setting of $f/11$. Which person do you focus on so that all persons will be sharp? When the infinity mark on your distance scale is set opposite the $f/11$ line on the depth-of-field-scale, the near plane is at approximately 13 feet. Thus by

Figure 101. Setting a lens for hyperfocal distance (maximum depth of field) at an aperture of $f/16$.

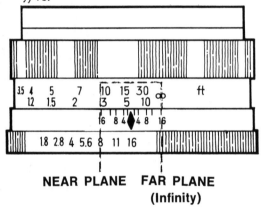

NEAR PLANE FAR PLANE
(Infinity)

Figure 102. Setting a lens for hyperfocal distance (maximum depth of field) at an aperture of $f/11$.

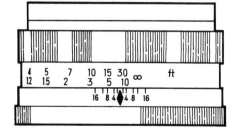

Figure 103a. Camera focused on foreground subject. Background out of focus.

Figure 103b. Camera lens set for hyperfocal distance with foreground subject placed at the near plane distance.

Figure 103. The use of a hyperfocal distance setting to achieve sharpness in both nearby and distant subjects.

using the hyperfocal-distance setting for $f/11$ you do not have to focus. All you need to remember is that if any person in the group is *closer* to the camera than 13 feet (the near plane), he will not be sharp in the photograph. So choose your viewpoint accordingly.

Another typical situation involves making a photograph of a person against a distant background. With your lens set at the hyperfocal distance for the f/stop you are using, the background will be sharply defined. The near plane distance as shown on the depth-of-field scale will tell you how far away you must be from the person to insure that he will be sharply defined in the final photograph.

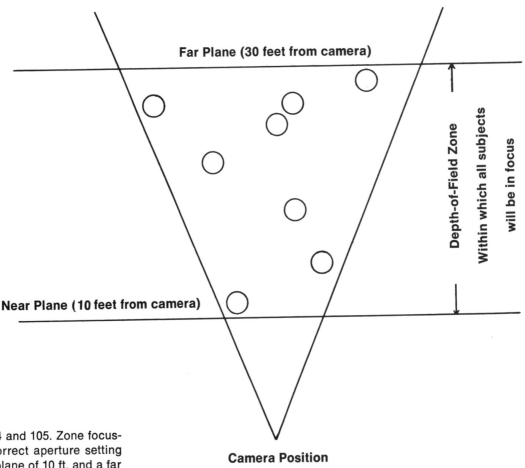

Far Plane (30 feet from camera)

Depth-of-Field Zone

Within which all subjects

will be in focus

Near Plane (10 feet from camera)

Camera Position

Figures 104 and 105. Zone focusing. The correct aperture setting for a near plane of 10 ft. and a far plane of 30 ft. (above) can be read from the depth-of-field scale

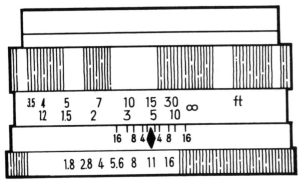

The same principle involved in using hyperfocal-distance settings is also used in what is called *zone focusing*. Suppose, for example, you are photographing a group of children at play. The near plane and far plane of the area they are playing in are 10 feet and 30 feet, respectively. To have all of the children in focus at all times your choice of camera-to-subject distance and lens aperture must be such that the entire zone from 10 to 30 feet is in focus as shown on the depth-of-field scale.

What particular distance within that range the camera lens is focused on is irrelevant.

76

SUPER-SHARPNESS

Let us return to the example of the fence extending to a distance of 100 feet from the camera. Refer back to Fig. 89 in which the camera was focused on a fence post 15 feet away and a lens aperture of $f/5.6$ was used. Posts from approximately 11 to 22 feet are sharply defined. Posts nearer than 11 feet are not sharply defined, and the nearer any post is to the camera the more blurred and indistinct it appears.

As we look down the line of posts each one is progressively blurred until we reach a post at 11 feet. This is the near plane of the depth of field, and all posts for the next 11 feet appear to be uniformly sharp. Beyond 22 feet blurring begins again and increases as the posts become increasingly distant.

Although we have described the posts within the depth-of-field zone as "appearing" uniformly sharp, actually they are not. The post on which the camera was focused (15 feet) is actually much more sharply defined than the posts at the near and far plane, but this greater degree of sharpness is beyond the ability of the human eye to discern. This "super sharpness" is the result of the fact that a good camera lens is capable of recording fine details far beyond what the human eye can see. What we actually have, therefore, within the depth-of-field zone is the reverse of the blurring condition outside of the depth-of-field zone. As blurring increases in accordance with how far *out* of the depth-of-field zone each post lies, sharpness increases in accordance with how far *into* the depth-of-field zone each post lies, with greatest sharpness at the plane the camera was focused on.

Figure 106 will help explain the actual conditions of relative sharpness in a photograph.

A camera lens can only be sharply focused on a single plane. Theoretically, any object slightly nearer or slightly farther away from the plane focused on will be "out of focus." To the human eye, however, such objects appear to be satisfactorily sharp and hence "in focus." The human eye can perceive nine or ten fine lines and spaces within

an area one-sixteenth of an inch wide. A good camera lens can perceive as many as several hundred lines within this small width. What we refer to as depth of field is actually the product of the remarkable ability of a camera lens to outperform the human eye in recording the finest of details and the limited ability of the human eye to perceive them. It is only when objects are so near or so far from the plane on which the camera lens is focused that they finally become sufficiently out of focus for the human eye to discern.

With respect to sharpness in photographs, this scheme of things indicates some useful possibilities. When photographing scenes in which all objects are at a considerable distance from the camera, up to and including infinity, do not use a hyperfocal-distance setting. While the hyperfocal setting gives the maximum depth of field, infinity is at the extreme limit of the depth-of-field zone and hence is just barely in focus. Setting your lens to a greater distance will improve the sharpness of objects at infinity by bringing them closer to the plane on which the camera is actually focused.

A similar situation exists when working at closer distances. If you are photographing a subject that has a near-to-far extent of 10 feet, do not work so close that the near and far planes of the subject are barely within the available depth-of-field zone limits. Objects lying at either the near or far plane of the depth-of-field zone are on the borderline of being out of focus. For improved sharpness the camera-to-subject distance should be increased or the aperture decreased to bring the near and far planes of the subject well within the depth-of-field zone, and hence closer to the plane on which the camera is focused.

There is one further aspect of super sharpness that should be kept in mind when selecting an appropriate lens aperture to meet depth-of-field requirements or to meet lighting or other requirements. There is a widely held misconception that the smaller the lens aperture used, the sharper the resultant photograph. This was once true with certain types of lenses, but it is not true with modern lenses. The use of very small lens apertures can actually introduce some loss in sharpness. At what particular aperture a camera lens is functioning at optimum sharpness can only be determined by careful testing and will vary with the speed of the lens. A good rule of thumb to follow is that where maximum sharpness is needed, both large

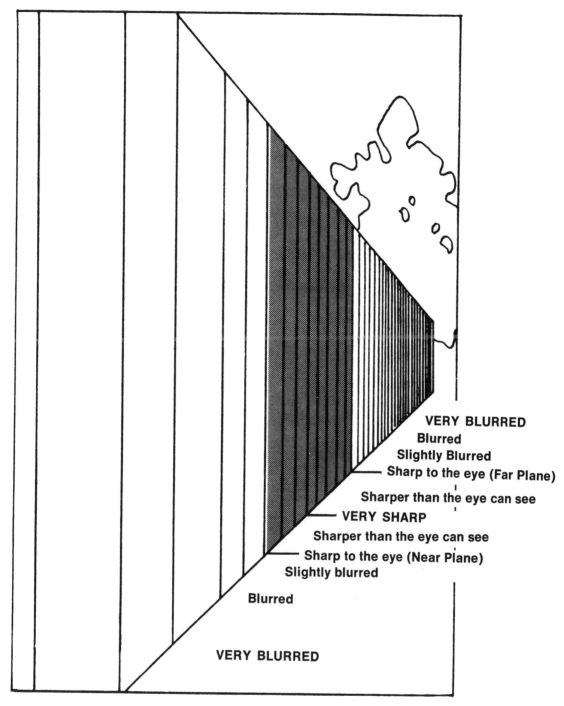

Figure 106. "Supersharpness."

aperture settings as well as very small ones should be avoided. Specific recommendations on the aperture setting for maximum sharpness for any particular lens can be obtained by writing to the lens manufacturer.

THE LIMITATIONS OF THE RECORDING MEDIUM

Many amateur photographers find that some of their color slides are disappointing or downright failures. They wonder why the highlight areas in some slides appear to be bleached out, or why the shadow areas in others appear to be much too dark. Beginners are always asking themselves: "What went wrong?" or "What mistake did I make?" The answer may well be "Nothing." There are scenes that simply cannot be captured on film as the human eye sees them regardless of the cost of the camera used or the amount of skill devoted to the shot. The reason is that nature is capable of presenting us with a range of light intensities from dark to bright which at times is quite beyond the capability of any film.

Let us use a scale of ten squares to represent the maximum range of tones that a film can record (Fig. 107). Films can record far more than ten tones of course, but a scale of ten will serve to illustrate the principle. Let us now assume that the range of brightness from shade to full sun on a typical sunny day extends from tone 2 through tone 9 (Fig. 108). Such a scene would thus be within the tone-range recording ability of the film.

80

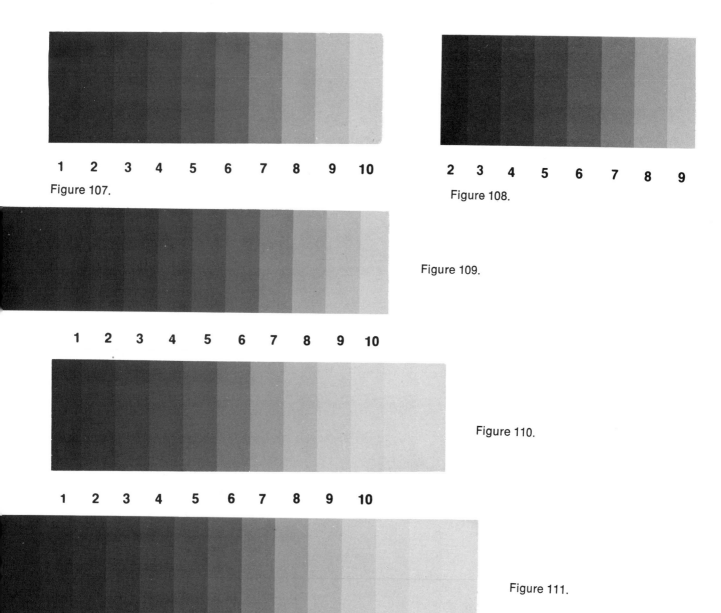

Figure 107.

1 2 3 4 5 6 7 8 9 10

Figure 108.

2 3 4 5 6 7 8 9

Figure 109.

1 2 3 4 5 6 7 8 9 10

Figure 110.

1 2 3 4 5 6 7 8 9 10

Figure 111.

1 2 3 4 5 6 7 8 9 10

If, however, the brightness range of a given scene is greater than the range of ten tones because of the presence of either some very dark areas (Fig. 109) or some exceptionally bright areas (Fig. 110), or both (Fig. 111), no exposure setting can record the full range of tones present.

A choice then must be made as to which is the more important to your picture—the highlight areas or the shadow areas. This problem is discussed in more detail in Chapter XII.

FILM SPEED

When you open a box of film for your camera you will find an instruction sheet for using the film. It states quite prominently, usually at the very top and in bold type:

Figure 112. ASA film-speed markings on instruction sheets.

With some films the ASA number is printed on the outside of the box and also appears on the cassette containing the film.

Figures 113a and b. ASA film-speed markings on film boxes and cassettes.

On your camera you will find a dial marked "ASA" accompanied by an extensive range of numbers (consult your owner's manual for its exact location).

The question naturally arises: What do all these letters and numbers mean? ASA stands for *American Standards Association*. This organization was established many years ago for the purpose of developing standard specifications for a wide range of products to insure industry-wide uniformity. A common example of the advantage of such uniformity to the consumer is the ordinary household light bulb and socket. Regardless of the manufacturer of either product, the consumer has the assurance that whatever brand of light bulb he buys, it will fit into all the sockets in his household. (The Association changed its name first to the United States of America Standards Institute then to American National Standards Institute, Inc. But the initials ASA have never been abandoned by photographers).

In addition to establishing standards for products, ASA has the responsibility for developing standard *methods* for testing and evaluating the performance of products. One of these is a standard method for testing the light sensitivity of photographic films.

There are many different types of film with different performance characteristics. These differences affect their sensitivity to the action of light. If you are to be able to set your shutter speed and lens aperture correctly with any given film, you must know something about how rapidly or slowly it responds to light. In a word, you need to know the film's *speed*. The numbers listed after the letters "*ASA*" tell you this, and follow a simple arithmetical relationship beginning at zero and going on up into thousands.

Most of the films commonly used in 35mm cameras have ASA ratings ranging from 25 to 400. A typical group from one manufacturer has ASA speeds of 50, 64, 80, 100, 125, 160, and 400. A film having a rating of ASA 100 is twice as fast as a film having a rating of ASA 50, and hence would require only half as much exposure. A film rated at ASA 64 would require twice as much exposure as one rated at ASA 125.

Exposure determination is usually accomplished in one of two ways—by means of general guidelines suggested by the film manufacturer or by the use of an *exposure meter*. Exposure meters (also called "light meters") are devices

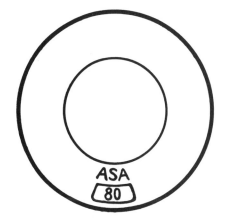

Figures 114a and b. ASA film-speed dials (enlarged).

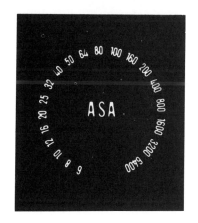

83

Figure 115. Combined DIN and ASA film-speed dial.

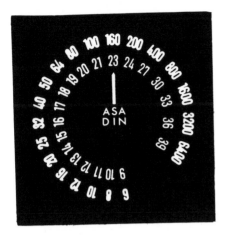

that measure the amount of light present. Many single-lens reflex cameras have built-in exposure meters. With those that do not, separate accessory meters can be used. Exposure meters and their uses are described in more detail in Chapter XII.

If your camera does not have a built-in exposure meter, the ASA scale on your camera serves simply as a reminder. You note the ASA rating printed on the film instruction sheet and set the scale accordingly. If you use an accessory-type exposure meter, then you must set the ASA scale on the meter to the correct number to get true readings of shutter-speeds and lens-aperture settings. If your camera has a built-in meter, set the ASA dial to the correct number. This is especially important because this dial is connected electronically to the meter and regulates the meter's indicator needle action in accordance with the ASA speed setting. If, for example, you changed from a film with a rating of ASA 50 to a film with a rating of ASA 160 and did not change the setting of the ASA dial on your camera, all your pictures would be overexposed.

In addition to ASA ratings, many films, particularly those of foreign manufacture, also list the letters "DIN" and a different number: 21 DIN = 100 ASA. The letters DIN stand for *Deutsche Industrie Norm*, which is the German counterpart to the American Standards Association. This organization has developed a different method for testing and evaluating film speed. You may even find that your camera or exposure meter has a set of DIN markings. This, of course, is for the benefit of those who use the DIN instead of the ASA system. One might hope that one day there will be but a single international system instead of the present two.

EXPOSURE DETERMINATION REALITIES

At the outset one must recognize and accept four facts concerning exposure determination of which all professional photographers are aware:

1. Despite recent improvements in electronic light measuring systems and devices, exposure determination for the average photographer still remains, after over 130 years, an inexact business.

2. To make a successful photograph several factors are involved of which exposure is only one. A picture made at the "correct" exposure may be a success in terms of exposure but a failure in every other respect.

3. The "correct" exposure may not necessarily be the best exposure in terms of the creative result. Deliberate departure from the "correct" exposure can often be a very useful and sometimes a very necessary device in making a photograph.

4. A perfectly accurate exposure is rarely needed.

It is safe to say that for a great deal of camera work a reasonably accurate exposure will suffice. In some situations, however, such as when photographing paintings, perfect color fidelity is sought and something better than

a reasonably accurate exposure is required. Control over exposure then becomes quite critical. Such situations, however, are exceptional. The average amateur photographer does not need such critical accuracy to obtain excellent results, nor does he need extensive technical knowledge. He does need experience. He needs to observe and to learn to make judgments. He needs to know *how* to use a light meter. He needs to know when to accept the verdict of the light meter and when to depart from it.

Various approaches to the problems of exposure determination will be explored and various methods will be examined. This will help to develop some useful guidelines to put exposure determination in its proper perspective.

Much too much emphasis has been placed, particularly in advertisements by camera manufacturers, on the importance of exposure. The impression given is that exposure determination is the only problem in making good photographs. If you use the camera advertised, you will have solved this problem. This is far from being the case. While a reasonably accurate exposure is usually necessary for making a successful photograph, other factors, such as depth of field, must also be taken into account. There are also situations in which an average exposure will yield nothing more than an average result whereas the deliberate use of under- or overexposure—theoretically "incorrect" exposure settings—might change an uninteresting record shot of a scene into a striking and dramatic statement. None of the various systems for exposure determination available to the amateur photographer can be thought of as automatic and infallible, guaranteeing a perfect result every time without any thought or effort on the part of the photographer. The exposure settings indicated by any system are better thought of as general rather than specific recommendations, which often need to be modified on the basis of experience, judgment, and intention.

EXPOSURE DETERMINATION METHODS

There are two basic methods for determining how to set your camera to obtain proper exposure. The first of these is by the use of the guidelines supplied by film manufacturers with each roll of film. The other is by the use of some type of "light meter" or "exposure meter" that will give a "reading" of the amount of light present. By means of scales, this reading can be converted into f/stops and shutter speeds.

The guideline method based on the film manufacturer's recommendations suffers from one serious drawback. The manufacturer can make recommendations for only a few very general kinds of lighting conditions and only in general terms. For example, exposure recommendations are often made for conditions described as "bright sun," "hazy sun," "cloudy bright," or "heavy overcast." It is up to the photographer to try to judge how bright, hazy, cloudy, or heavy the scene is he wishes to photograph. If his judgment does not agree with the film manufacturer's, his choice of exposure settings will be incorrect and his pictures more or less unsatisfactory.

A more reliable way to determine exposure is by means of a light meter. Light meters may be classed first according to whether they are accessory units, completely separate from the camera's functions, or are "built-in" to the camera itself. Accessory-type meters come in a great variety of sizes, shapes, and prices, but, for the most part, they all function pretty much in the same manner.

When the meter is pointed at the scene to be photographed, a needle moves across a scale of numbers in response to the light entering the meter. The more intense the light, the higher the number the needle will reach. By matching this number alongside a scale of shutter speeds and f/stops, you can read off various possible exposure combinations appropriate to the ASA rating you have pre-set.

Built-in meters evaluate the light passing through the lens of the camera and do not have scales against which numbers must be matched. Instead they usually have a

Figure 116. Typical exposure indicator systems as seen through the viewfinder.

small pointer or needle and only three markings, which can be seen when you look through the viewfinder of the camera. One mark is for correct exposure, one for overexposure (usually a "+" sign), and one for underexposure (a "—" sign). Some cameras have, in addition to a pointer, small windows within the viewfinder that show the actual f/stop, shutter speed, and ASA settings.

The operation of a built-in metering system is based upon changes in either the aperture setting of the lens or the shutter-speed setting until a combination is found at which the needle points to correct exposure. For example, when you shoot out of doors in fairly bright light, you might set the shutter speed for 1/125 sec. Then, rotate the diaphragm ring from setting to setting, and watch for the movement of the indicator needle in the viewfinder. At f/5.6 it might indicate overexposure, at f/8 the correct exposure, and at f/11 underexposure.

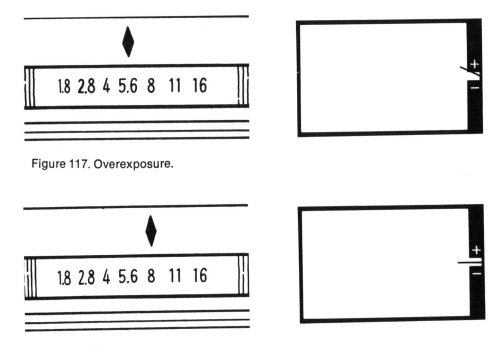

Figure 117. Overexposure.

Figure 118. Correct exposure.

Conversely, setting the lens aperture at f/8 and changing the shutter speeds, a speed of 1/60 sec. may indicate overexposure, a speed of 1/125 sec. may indicate correct exposure, and a speed of 1/250 sec. may indicate underexposure.

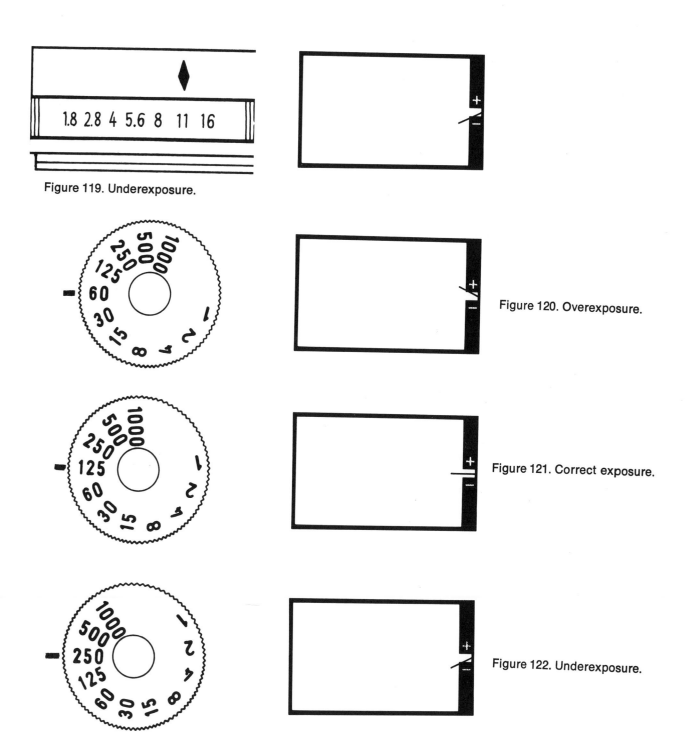

Figure 119. Underexposure.

Figure 120. Overexposure.

Figure 121. Correct exposure.

Figure 122. Underexposure.

There are a number of variations and refinements on this general scheme, depending upon the make and model of camera. But the basic objective is the same—to make exposure determination as rapid and simple as possible by working through the camera lens with an indicator system that simply says "yes" or "no."

EXPOSURE DETERMINATION TECHNIQUES

For the most part, exposure meters, whether accessory or built-in, are "averaging meters." The movement of the indicator needle is in response to the *average* amount of light reflected from a given scene including both bright highlight areas and dark shadow areas and everything in between. This averaging method does not solve certain problems, however, which, if not understood, can result in unwanted over- or underexposure.

The behavior of a built-in averaging meter can be demonstrated quite simply by placing two sheets of paper, one black and the other white, side by side. The procedure is as follows:

1. Position your camera so that the area seen through the viewfinder (and hence the light meter) will include equal areas of black and white. Adjust the aperture and shutter speed to determine what the correct exposure should be and make a note of the settings (Fig. 123).

2. Now position your camera so that the area viewed is approximately seven-eighths black and one-eighth white. Adjust the aperture and shutter speed accordingly and make a note of these settings (Fig. 124).

3. Now position your camera so that the area viewed is approximately seven-eighths white and one-eighth black. Again, adjust the aperture and shutter speed and make a note of these settings (Fig. 125).

You will note that although the lighting conditions are constant, the light received by the meter varies according to the proportions of black and white in the subject. This, in turn, causes the exposure settings indicated by the meter to vary considerably.

Translating the data derived from this experiment into a practical and fairly common photographic situation, let us assume that a scene you wish to photograph includes approximately equal areas of light, shade, highlights, and shadows. Your averaging meter will indicate an exposure setting that will do justice to each area. But suppose that you recompose the same scene under the same lighting conditions to include a much larger proportion of the highlight area and a much smaller proportion of the shadow area. Your averaging meter will duly

Figure 123. "Reading" a half-black and half-white subject.

Figure 124. "Reading" a mostly black subject.

Figure 125. "Reading" a mostly white subject.

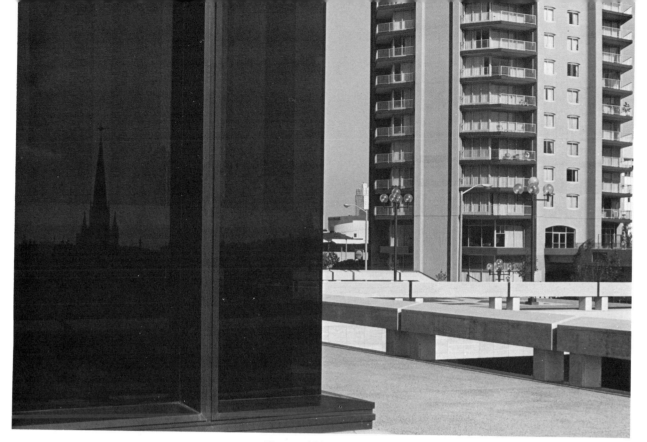

Figure 126. Taking a meter reading of approximately equals of highlights and shadows.

Figures 126, 127 and 128. Averaging. By taking a meter reading from a portion of a scene that includes approximately equal areas of highlight and shadow as in Figure 126 above, an average exposure setting can be determined that will yield optimum detail and tonal values in both areas, regardless of whether the final composition selected includes a larger proportion of highlights or shadows, as shown in Figures 127 (below), and 128 (next page).

Figure 127. Taking a reading of an area where highlights predominate.

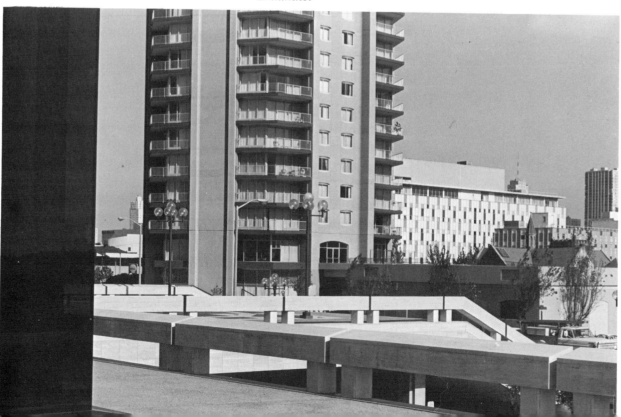

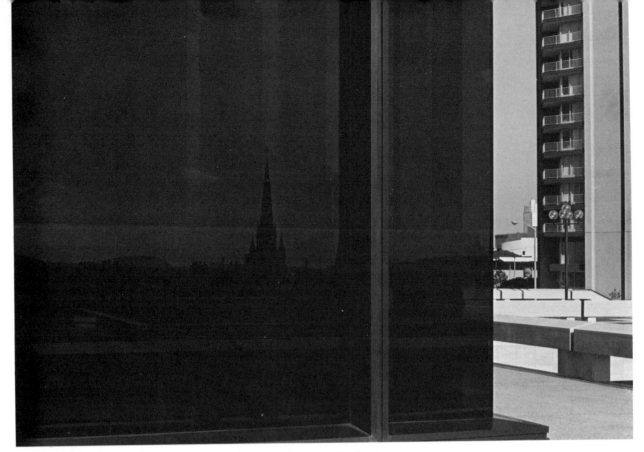

Figure 128. Taking a reading of an area where shadows predominate.

respond to the higher proportion of brightness from the highlight area. It will indicate that a smaller aperture or a shorter exposure interval should be used, which will result in the shadow areas being substantially under-exposed. If you recompose your picture again so that the proportion of shadow area far exceeds that of the high-light area, the meter will indicate the need for a larger aperture or a slower shutter speed, which will result in the highlight areas being substantially overexposed.

A simple rule of thumb regarding the way to use an averaging meter now becomes apparent:

Because the meter *averages* the brightnesses of a scene, if you wish an average recording of both highlights and shadows, you must base your exposure determination on an arbitrary selection of areas of highlights and shad-ows. In other words you must present the meter with your own selection of an average of the prevailing bright-ness conditions, weighted neither on the shadow side nor on the highlight side. Because the meter always averages, you must be sure that what it reads is a truly representa-tive average of the lighting conditions present.

92

Figure 129. Taking a close-up reading of a shaded subject against a bright background.

Figure 130. Taking a close-up reading of a bright subject against a shaded background.

If, however, the main subject you are photographing is in the shadow area of a scene, then you must be careful to exclude from the meter's view any substantial proportion of highlight area. This may require moving in close to your subject to make the exposure determination in order to exclude the unwanted influence of highlight areas on the meter. You can then back off and compose your picture. The opposite would be true if the principal subject is in a bright highlight area of the scene. In this case the unwanted influence of shadow areas on the meter's reading must be avoided.

Figure 131. Area read by a spot meter.

There is another important exception to the procedure of providing an averaging meter with an average of the light conditions present. This occurs when the range of brightness in a scene is extreme. As was described in Chapter XI, there are situations in which the brightness conditions exceed the recording capability of any film. Under such circumstances a perfect average exposure would result in the loss of both highlight and shadow details beyond the limits of the range. Consequently a choice has to be made between favoring the highlights or favoring the shadows. If detail in the shadows is more important, then the data supplied to the meter for reading must be "weighted" on the shadow side. In other words, a greater proportion of shadow area must be included in the area the meter is to read. If the shadows are all important and the highlights of no consequence, then the area to be read by the meter must include nothing but shadow areas. Conversely, if the highlights are important, the data supplied to the meter for reading must be "weighted" on the highlight side, with a relatively small proportion of shadow area included. If the shadow details are completely unimportant and the dark areas only serve to emphasize the highlights in the form of black shapes or silhouettes devoid of detail, then only highlight areas should be read.

To provide some degree of improvement over the performance of averaging meters without involving the user in matters of judgment, some single-lens reflex cameras are equipped with what are called *weighted meters*. When the proportion of highlight area to shadow area is considerably unequal, such meters adjust their readings to compensate for the imbalance. But, even with weighted meters, judgment and selection are still necessary.

Another kind of meter that offers a different approach to the solution of the problem of exposure determination is the *spot meter*. Spot meters can be either an accessory or a built-in meter. They are designed to read the light intensity of only a very small area of a scene. As with other light measuring systems, a spot meter has advantages and disadvantages. One advantage is its ability to read, even at some distance, the relative brightness or darkness of relatively small areas in a given scene. Only

94

Figure 132. Reading the brightness range with a spot meter.
A. Shadow-area reading. B. Highlight reading.

the highlight areas or only the shadow areas can be read and an exposure determination made in terms of the relative importance to the picture of the one area or the other. Spot meters read only one very small area, so be certain to use discretion when deciding what area to use as the representative of the average brightness in the scene. An alternative method for using a spot meter to determine an average for a given scene is to take readings from the brightest area and then from the darkest area and select an exposure between the two extremes that will be an average.

Still another "averaging" device for exposure determination is a cardboard sheet manufactured by the Eastman Kodak Company called a Kodak Neutral Test Card. Although designed primarily for color photography under artificial light conditions, the neutral test card can be useful in other situations as well. The card is white on one side and gray on the other. The gray side is a selected tone between white (highlight) and black (shadow) and

95

Figure 133. Taking a reading from a gray card.

hence is an "average" tone. By reading the light reflected from the gray side with a light meter, you can obtain an average reading (Fig. 133).

Still another type of light meter is one that measures the amount of light *falling* on a scene instead of measuring light *reflected* from it. Such meters are called *incident-light meters* to distinguish them from the *reflected-light meters* we have been discussing. The incident-type meter tends to be more in the class of professional equipment. Also, such meters can be quite expensive. A good one can cost as much as a good camera. The trend in meters for single-lens reflex cameras has been toward improvements and refinements in the use of reflected-light meters.

But regardless of whether one uses an accessory meter, a built-in meter, an averaging meter, a "weighted" meter, a spot meter, an incident- or reflected-light meter, or a gray card of average value, none will assure perfect exposure determination for all subjects every time. At best, the readings such exposure determination systems provide must be considered as aids and pointers that help to approximate the proper camera settings under a given set of light conditions.

It is the nature of the world of light we live in that an infinite variety of lighting conditions are constantly being presented to us, each one revealing the visual world in a different way at any given moment or with any change in our vantage point. We see light *qualitatively* in terms of light, shade, and a rich range of colors. Light meters see light *quantitatively*. To use a light meter to its fullest advantage, we must recognize this difference and learn through experience, observation, and judgment how best to use a *quantitative* measurement supplied by a light meter to obtain a *qualitative* result.

To return once again to the controls on your camera in relation to exposure determination, if your camera does not have a built-in meter, the only "control" will be an indicator dial to remind you of the ASA speed of your film. If it does have a built-in meter, you must remember always to set the ASA dial to the correct rating. If you fail to set the ASA dial correctly, your meter will not give you correct readings. A built-in meter is powered by a small battery and is electronically controlled. Your owner's manual or your camera dealer can tell you where the battery is located, how to test it, and how and when to replace it. Since the meter is battery-powered, it is important that it be "on" only when exposure readings are being made. It is therefore equipped with an "on" and "off" switch, the location and operation of which you should also be familiar with. Again, your owner's manual or camera dealer can be of help. With the ASA dial set correctly and the switch in the "on" position you are ready to try exposure determination readings. To bring the indicator needle to "correct" exposure, a certain combination of f/stop and shutter speed is required.

A typical set of instructions for exposure determination from an owner's manual might read as follows:

"The meter pointer moves upward or downward with the rotation of the lens-aperture ring. When the needle rests at the center you will get correct exposure. If the needle does not come to the center no matter how far you turn the diaphragm ring, change the shutter speed."

It sounds very simple. However, as has been pointed out before, correct exposure is not the only element that

makes a successful photograph. To illustrate this, let us suppose your shutter speed is set at 1/125 sec. and you are trying to photograph a group of people at varying short distances from the camera under relative dim light conditions. You rotate the lens-aperture ring and even at the maximum aperture (for example, $f/1.4$) the needle still has not come to the center. So, following the instructions given, you change to a shutter speed of 1/60 sec. Now, at an aperture of $f/1.4$, your meter needle does rest at the center. Press the shutter release and you will get a correctly exposed picture. But, if you check back to the depth-of-field lessons, you will recall that depth of field at an aperture as large as $f/1.4$ is very shallow at close working distances. Perhaps one person in the group will be sharply defined and all others hopelessly blurred because of the lack of depth of field. The exposure was correct but the picture was nonetheless a failure.

Let's suppose now that you have learned your lesson. On another occasion you attempt the same picture but this time with due regard for depth of field. To have all your subjects within the depth of field zone, you must use an aperture of $f/11$. In this case you rotate the shutter-speed dial until the needle comes to rest at center and then press the shutter release. Again, you have a correctly exposed picture, but everyone in the picture is blurred. The cause for this is simply that the shutter speed that matched the lens-aperture setting of $f/11$ under the existing light conditions happened to be one full second, and rare indeed is the person who can hold a camera steady for that long.

The lesson to be learned from these two examples is obvious. You, the photographer, must evaluate what your meter tells you about light conditions. Then you must decide on what combination of $f/$stop and shutter speed you will need to get the picture you want. In other words you have to make your own judgment and then tell the camera what to do. Good results can hardly be expected if you let the camera tell you what to do.

XIII. Understanding Films

TYPES

There are a number of different types of films available for 35mm photography. They can be classified in a number of ways. First of all they can be grouped according to whether they are for black-and-white or color photography. These groups can be further subdivided according to the purpose or function for which the different types of films are intended.

Earlier, in the introduction to *exposure,* mention was made of "negative" and "positive" images. If you examine a roll of black-and-white film that has been developed, the images are negative. The tone values are reversed. Highlight areas such as a bright sky are virtually black, whereas dark objects of shadow areas are very light and transparent. If you then examine developed color film in the form of slides for projection you will note that the images are positive. The tone values are in their correct relationship. Why this difference?

When light rays from the subject you are photographing strike the surface of the film in your camera, they act on it in proportion to their brightness or intensity. When properly exposed, the brighter the object, the

Figure 134a through c. Typical exposure counters.

darker its image will be on film. When a black-and-white negative is printed on a sheet of photographic paper, the same effect occurs. Light is passed through the negative to the photographic paper. Dark areas in the negative pass very little light and hence record as light tones whereas the more transparent shadow areas pass much more light and hence record as dark tones. The resulting print, a negative of a negative, thus becomes a positive.

Color slide film in your camera also records a negative image, but in the process of development the negative image is converted into a positive image.

One of the first facts about films you will encounter, aside from film type, is film *length.* Films for 35mm cameras are normally spooled in lengths of 20 or 36 exposures. Both the box and the cartridge containing the film are clearly marked as to the number of exposures. Your camera is equipped with an *exposure counter* or *frame counter,* which will keep you informed of how many exposures you have made and how many you may have left before you have to reload. On some cameras you must remember to set the exposure counter back to "0" when a new roll of film has been loaded. On others the counter returns to "0" automatically.

Film data sheets, enclosed in the box of film, give basic information, starting with a brief description of characteristics of the film and the ASA rating and continuing with various exposure recommendations for different light conditions, how to use the film with filters, flash bulbs, and electronic flash, and processing information. Until you get to the stage when you are ready to use accessories such as filters and flash illumination or are at the point where you process your own film, the most important single piece of information on the data sheet will be the ASA rating. Set the ASA dial on your camera accordingly.

Figure 135.

The largest group of black-and-white films are those intended for general photography. Within this group are films that differ from each other with respect to two main characteristics. These two characteristics are speed and "grain size." In terms of sharpness, grain size (or granularity as it is also called) is an important factor when the image is going to be enlarged a great deal.

When you hear or read of a film described as "fine-grain" or "coarse-grain," it refers to the use of the word "grain" as used to describe the texture of sand. The surface of a developed piece of photographic film is not a smooth, homogenous surface. It is made up of a large number of very small grains. If a black-and-white negative is magnified or enlarged a sufficient number of times, this granular structure begins to show, causing smooth, continuous tonal areas to have a coarsened or "grainy" appearance.

In general, fine-grain films have a relatively slow ASA rating, but such films can be enlarged to greater size before grain structure begins to show. High speed films, on the other hand, achieve their speed at the expense of fine grain and hence cannot be enlarged as many times without the grain structure of the film becoming apparent in the print. Between these two extremes there are medium-speed films that strike a compromise between fine grain and speed. While learning to understand your camera, it is best to stay with a medium-speed film, but, what is even more important, *do not switch from film type to film type or from brand to brand until you have developed some proficiency in the use of your camera.* By now you must be aware that there are a number of variables you must work with and become familiar with if you are to understand your camera. Changing film types, speeds, and brands introduces more variables that can only lead to confusion rather than to enlightenment.

In addition to the family of general-purpose films there are special-purpose films such as films of extremely high contrast for copying drawings or printed matter or films of very high speed for photography at very low levels of illumination. One special-purpose film has its unique characteristics and requires a special marking on your lens. This film is highly sensitive to infra-red rays.

Infra-red rays are invisible to the human eye and fall within a transitional area between light rays, which one

can see, and heat rays, which one can feel. Just as an X-ray can pass through solid matter as if it were not there, a distant mountain range completely obscured by atmospheric haze can be revealed with remarkable clarity by means of infra-red-sensitive film used with a deep red filter. Infra-red rays do not focus on the same plane as do visible light rays. Your camera lens has a mark on the depth of field scale in the form of a small "r" or a red line or arrow that tells you where your focus setting should be for sharp focus when using infra-red film. The procedure is simply to focus on the visible scene as you normally would and then, just before taking your picture, move the footage setting opposite the normal focus arrow to a position opposite the infra-red marker.

Most of the principal film manufacturers supply one or more kinds of color film. Each differs somewhat in color balance, film speed, and other characteristics. As to color balance, the choice of which color film to use is largely a matter of personal preference. As for film speed, this too is a personal choice that will depend on individual requirements. Obviously if you enjoy photographing high speed action such as indoor sports events where the light level is low, you will want the fastest film you can obtain. Color films are classified as "daylight-type" and "tungsten-type" film. Daylight-type film, as the term suggests, is used where direct or reflected light from the sun is the source of illumination. Tungsten-type film is used under artificial-light conditions where various kinds of electrical-light sources are used to provide illumination. Different types of tungsten film are available for use with different types of electric-light sources. Most color films can be converted for use with a light source other than the one for which they were originally intended. This is done by means of a conversion filter, which is placed over the camera lens.

Another type of color film is called *color negative*. This film was designed primarily for making color prints on paper, although excellent slides can be made from it. Developed color negative film has a most peculiar appearance. Not only is the image negative in values but it is made up of only two colors—orange and green. It is hard to believe that this strange looking film can yield color prints covering the entire range of the visible color spectrum.

LATITUDE

When we discussed depth of field, we said that theoretically only one plane in a picture is truly in focus. Any plane nearer or further from the plane focused on will be less sharp than the plane focused on. It was also pointed out that such differences in sharpness are not discernible to the human eye and are considered to be acceptably sharp.

A similar situation exists with respect to exposure. There can be only one "correct" exposure for any given scene. Any degree of over- or underexposure, no matter how slight, would be an "incorrect" exposure. Here again, however, partly because of the characteristics of film and partly because of the way the human eye and brain work, practice differs from theory.

Fortunately, most camera films for general photography have a fairly generous endowment of what is called *exposure latitude*. Exposure latitude simply means that you can under- or overexpose on either side of the optimum exposure setting for a given scene and still end up with highly satisfactory results. In other words, should you err a little in your exposure determination, all is not lost. Under average lighting conditions you may still end up with a perfectly satisfactory print from a black-and-white negative even if it was over- or underexposed by as much as one full f/stop. With color film, one-half an f/stop is usually the limit. The presence of exposure latitude should not, however, be used as a crutch for careless workmanship. The *best* results will be obtained at the *optimum* exposure setting. Every effort should be made to determine the optimum exposure for a given scene, but should the settings you choose be somewhat off the mark, exposure latitude will, in many cases, protect you.

There is another form of latitude that is psychological and that manifests itself particularly in color photography. This can be demonstrated by making three exposures on color film of a red barn in a setting of evergreen trees with brown trunks and a blue sky in the background. Once you have determined what the correct expo-

sure setting should be, make the first exposure at a lens setting one-half stop below the correct setting, make the second exposure at the correct setting, and the third at a setting one-half stop above the correct setting. When you show any one of these slides to people, no one will detect exposure faults. Despite some degree of over- or under-exposure, the essential relationship that your audience expects between the redness of a barn, the greenness of evergreens, the brownness of tree trunks, and the blueness of sky has been preserved. The fact that the colors are not perfectly true would go unnoticed unless all three slides were shown at the same time.

Still another form of "latitude" that will protect you from losing an important and perhaps unrepeatable picture is a device widely used by professionals called *bracketing*. Bracketing simply means deliberately doing what was done in the red barn series. When in doubt about the correct exposure setting, make two additional exposures: one a half stop on the underexposure side and one a half stop on the overexposure side. On occasion you might want to go as far as a full f/stop if circumstances seem to warrant it. Whereas this uses more film, the results often justify it. If, for example, you have invested a thousand dollars in a trip abroad, a few extra pennies spent every now and then on bracketed exposures may make the difference between a complete and an incomplete record of your travels.

Up to this point the discussion on exposure latitude has been based on "average lighting conditions." This phrase needs further defining. "Average" means *moderate* in terms of the *range* of light intensities present in a scene, the opposite of which is *excessive*. One can have, for example, scenes of intense brightness such as at a beach on a day when there is a light overcast, but everything in the scene is relatively bright. Hence the range of light intensities is moderate. In full shade the range of intensities is also moderate, ranging only from low to medium intensities. When the range of light intensities is great, exposure latitude is diminished to the vanishing point and even beyond the vanishing point if the range is excessive.

The reason for this is simply that any given film can, at best, only record with reasonable fidelity a certain finite range of light intensities. If the scene you are photographing has a long range of light intensities from dark

shadow areas to very bright highlight areas, it may well be at the limit of what your film can record. A half stop overexposure will cause highlights to have a bleached appearance with no detail present. A half stop under-exposure will cause shadows to be too black and devoid of detail. In such situations bracketing is highly desirable to ensure an optimum result because of the difficulty in accurately determining the precise exposure setting that will record both the deep shadow areas and the bright highlight areas.

Beyond this lies those scenes "beyond the vanishing point" whose range of intensities is beyond the ability of your film to record in a single picture. There is no single exposure setting that will do the job. Loss of detail in either the highlights or shadows is inevitable. Here a decision must be made. Which is more important: the highlights or the shadows? If it is the highlights, use a lens and shutter speed setting that will not overexpose them. In other words, deliberately underexpose. If the shadows are more important, use a lens and shutter speed setting that will not underexpose them. Deliberately overexpose.

Figures 136 and 137. The actual size of the image recorded on film
in a 35mm SLR camera (right) and an enlargement (below).

XIV. Understanding Sharpness

MOVEMENT

Movement and *motion* are two factors that a photographer must be constantly aware of. *Movement* refers to what you and your camera might do. *Motion* refers to what the subject is doing. First let us consider movement.

In your hands is an instrument that you are going to use to convert a large area full of details to a very small area indeed—a scant 24×36mm (1″×1½″). Many of the details recorded on this piece of film will be much too delicate to discern with the naked eye. If such details are to be sharply defined on the film, there should not be any movement of the camera during the exposure. A very slight movement would seriously degrade the clarity of the film image. Camera movement, or "camera shake" as it is often called, is one of the commonest causes of poor quality photographs. Yet, it is one of the easiest to guard against once its importance is understood. There are a number of simple techniques you can use to eliminate camera movements, beginning with the use of a fast shutter speed. However, when circumstances require a slow shutter speed, you can use some type of support to keep your camera steady.

A shutter speed of 1/125 sec. is a fairly safe speed for "hand-held" pictures provided reasonable care is given to holding the camera as steady as possible. Where conditions will allow it, a shutter speed of 1/250 sec. is even better. A speed of 1/60 sec. will also work if one is especially careful about camera movement. At 1/30 sec. we begin to get into the "danger zone" for hand-held pictures.

The principal sources of movement that can make hand-held pictures unsharp are:

1. Finger movement
2. Head movement
3. Arm movement
4. Body movement

If you "snap" your picture with a short, sharp downward movement of your finger, a slight jarring of the camera can occur. An expert marksman never "pulls the trigger" of his gun. He gently squeezes it. The shutter release of your camera should also be gently squeezed, not "snapped," until it releases. The only exception to this occurs when you are photographing high-speed action where split second timing is important. In this situation you have the additional protection against unwanted camera movement because you usually use very fast shutter speeds, such as 1/500 sec. or 1/1,000 sec.

Movement of your head must be guarded against because your camera is pressed against it as you look through the viewfinder. If your head is steady, it can serve as a support against which the camera can be firmly pressed. This is particularly important when shooting vertical format pictures because the camera presses firmly against your forehead. At shutter speeds slower than 1/60 sec. you can improve steadiness by pressing your head against a firm surface such as a wall, post, or tree trunk.

When you make hand-held pictures do not let your arms "float free." Instead, bring them against your chest for support and hold your breath momentarily just before squeezing the shutter. When you shoot at a shutter speed of 1/60 sec. or slower, try to arrange a way to prop your elbows on a firm surface, such as a table top, chair back, or a railing, so that it is supporting the full weight of your arms. Arm movement is particularly noticeable if muscle fatigue develops. If you hold your camera for a lengthy period of time focused on a subject, waiting for

Figure 138. Pressing the camera against the forehead for greater steadiness.

Figure 141. Supporting the elbows for added steadiness.

Figure 139. Pressing one's head against a firm surface for greater steadiness.

Figure 142. Pressing the camera against a firm surface for greater steadiness.

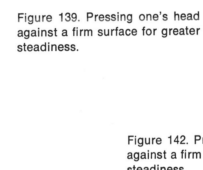

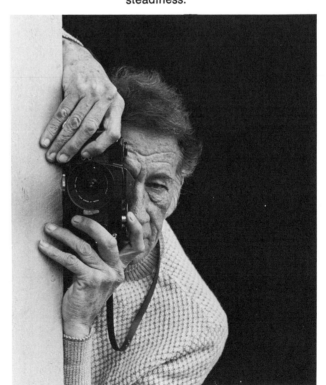

Figure 140. Pressing elbows against the body for greater steadiness.

just the right moment or the right expression, you will find it increasingly difficult to hold the camera steady. If the time is prolonged, you may find your arms actually shaking.

Body movement can be minimized if your body is in a comfortable position. If the position you adopt is awkward or strained, the chances of body movements are much greater. As in controlling head movement, resting or pressing your body against a firm surface for support can be very helpful in eliminating body movement.

Still another method that is extremely useful for hand-held photography, even for exposures as long as one full second, is to press the camera itself against a firm surface with enough hand pressure to eliminate any movement during the exposure.

Under conditions when slow shutter speeds must be used, because of either insufficient light, the use of a slow film, and/or the need to use a very small aperture, a tripod must be used. Even with a tripod certain precautions must be observed.

The tripod must be sufficiently strong and sturdy to support the weight of your camera without any shakiness or vibration. The legs of the tripod must be placed on a firm surface. If you are working on a sandy beach, for example, where the surface is not firm, the tripod legs should be pushed into the sand until they are firmly seated. An alternative would be to place pieces of driftwood or stones under the tripod legs. One of the most annoying surfaces to work on is thick, deep pile carpeting, which is manufactured specifically to be resilient rather than firm.

Many tripods are equipped with two sets of leg tips—pointed metal tips and rubber tips. Each has its advantages, depending upon the surface, for preventing the tripod legs from sliding. Tripods usually have telescoping legs made up of from two sections to six or more sections fitting neatly inside each other. Many tripods also have an "elevator," which is a column that can be manually raised or lowered for rapid and accurate adjustment. The tripod head to which the camera is affixed is least stable and most sensitive to vibration when the legs are at the fullest extension and the elevator is at its highest setting. In testing out a tripod for stability, extend it with a camera in place to its maximum height.

Figure 143. A typical tripod.

Figures 144 and 145.

Tripod leg tips.

110

Figure 146. Telescoping tripod legs.

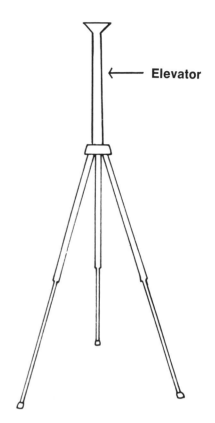

← **Elevator**

Figure 147. Tripod with elevator column.

Figure 148. A good, long cable release.

Even with your camera on a tripod, releasing the shutter can introduce some slight movement or vibration. At slow shutter speeds the use of a *cable release* can reduce this hazard. A cable release is simply a flexible cable that has a screw thread at one end that attaches to your shutter release and a push button at the other that actuates the shutter. The flexibility of the cable release does much to eliminate any movement that otherwise might be introduced at the moment the shutter is released. Cable releases come in many lengths from a few inches to several feet. Short cable releases have the least flexibility and hence should be avoided. A cable release of around 18 inches or more provides the needed degree of flexibility.

The important thing to remember when using a cable release is to allow it to be slack and completely free from tension. Any tension or pull on the cable release can impart movement to the camera when the release button is pressed.

When you are working with shutter speeds below 1/30 sec., solidity in a tripod is important for another

Figure 149. Keeping the cable release flexible.

Figure 150. Tension on a too-short cable release can cause camera movement.

reason. At the moment of exposure, three mechanical events occur within the camera that can introduce some degree of vibration:

1. The mirror springs out of the field of view of the lens.
2. The automatic diaphragm closes.
3. The shutter opens and closes.

If the tripod is too light and flimsy in construction, these mechanical actions within the camera may cause your picture to be slightly blurred.

The greatest cause of vibration of the three mentioned is the movement of the mirror. Some cameras are equipped with a lever or button that permits you to swing the mirror out of the field of view manually before releasing the shutter. If your camera has this feature it should always be used for exposures shorter than 1/30 sec.

112

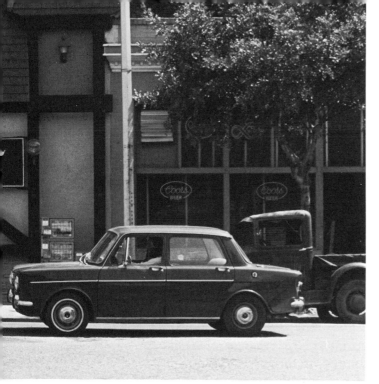
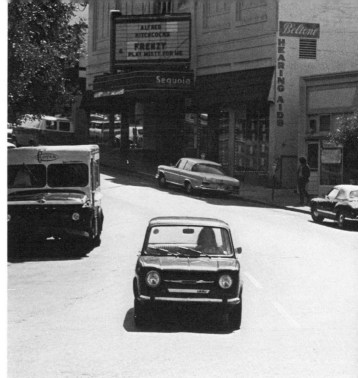

Figure 151. Subject in motion moving directly across the field of view. Figure 152. Subject moving directly toward the camera.

MOTION

The control or "freezing" of motion in subjects that are not at rest depends upon three aspects of motion:

1. The direction of the motion with respect to the camera.

2. The speed of the motion.

3. The distance between the moving subject and the camera.

We thus have three variables to contend with.

Direction

Subjects in motion may move directly across the field of view, directly toward or away from the camera, or may move at an angle to the camera.

At any given speed and distance from the camera, subjects moving directly across the field of view require a faster shutter speed to "freeze" motion than subjects moving toward or away from the camera at an angle.

Subjects moving directly toward or away from the camera can be "frozen" at lower shutter speeds than subjects moving directly across the field of view or at an angle to the camera.

113

Speed

The faster the subject is moving, the faster the shutter speed needed to freeze the motion. However, the same rules of thumb given concerning the direction of the movement also apply.

Distance

For a subject moving at a given speed, the closer it is to the camera, the higher the shutter speed necessary. Also, the direction of the movement of the subject is an important factor. For example, an automobile moving across a landscape at some distance might be frozen at 1/125 sec., but if it is to be photographed at a distance of a few yards as it goes past the camera, even the fastest shutter speed you can use—1/1000 sec.—will not freeze the action.

There is one situation in which both movement and motion are combined to "freeze" motion. When photographing high speed action, such as racing in its many forms, the photographer "pans" with the moving subject. For example, when photographing a racing car crossing the finish line, a photographer will frame the car in his viewfinder as it approaches and then steadily move the camera to keep the car in view until the moment he releases the shutter. At this point both the camera and the car are moving rapidly but synchronously, and continue to move together as the exposure is made. Extraordinarily sharp pictures of high speed subjects at relatively close distances can be obtained by this simple technique. Because of the camera's motion, stationary objects in the foreground and background will be blurred, but pictorially this can often work to advantage since the frozen motion and sharp detail of the car stand out strongly against the unsharp surroundings. Also, the blurred lines help to convey a sense of speed. Were every detail in the picture uniformly sharp the picture would hardly differ from one taken of a parked car.

The feeling of speed that blurred background lines convey introduces another aspect concerning the photography of subjects in motion. Often the use of a slower shutter speed with the deliberate intention of introducing some degree of blurring from movement is a very effective method of conveying to the viewer a sense of movement in a still picture. A slight degree of blurring in a picture of a racing car whipping through a turn, or an on-

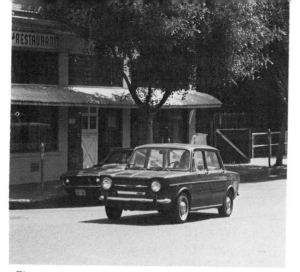

Figure 153. Subject in motion moving toward the camera at an angle.

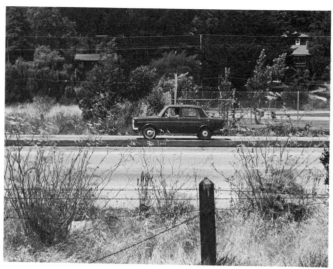

Figure 154. Subject in motion moving directly across the field of view at a distance.

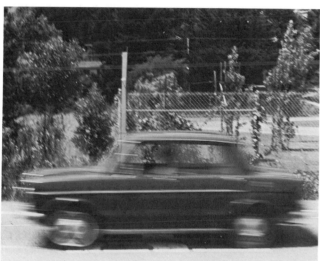

Figure 155. Subject in motion moving directly across the field of view at close range.

Figure 156. "Panning" a subject in motion makes it possible to stop even high-speed motion.

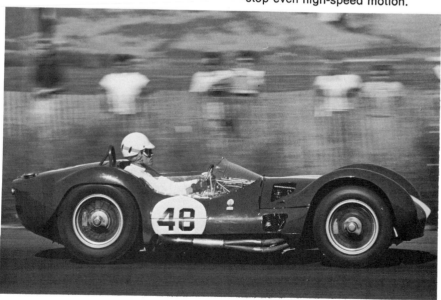

rushing train, or the swirl of a flamenco dancer's skirt often will make a more successful picture than one in which all movement has been frozen into the appearance of a statue.

Thus far the discussion of the photography of moving subjects has been predicated on the use of the standard lens supplied with SLR cameras. In addition to the three factors described, there is a fourth factor that must be taken into account when using long focal-length or telephoto lenses. The use of such lenses creates the same effect on film as if the camera-to-subject distance were much shorter than it actually is. Hence moving subjects photographed through such lenses must be treated, in terms of shutter speed, as if they were at the close distance such lenses make them appear to be.

A basic consideration in photographing subjects in motion is, of course, the choice of shutter speed. Here again individual judgment and intention must come into play. Since high-speed action is, by definition, taking place at high speed, there is no time to measure speed, distance, angle, and direction. The only rule of thumb, therefore, is to shoot at the fastest speed (shortest shutter interval) that you can, unless you deliberately choose to incorporate some blurring to suggest rapidity of movement.

XV. Understanding Your Subject

APPROACHES

The first and most important consideration that you must be constantly aware of in your approach to any subject is the fact that your camera lens will record *everything* within its field of view—not just those portions or elements that have caught your attention. Some of the elements may be in focus and some out of focus, but all elements will be present. The human eye can be very selective in seeing things. In a field of grass it will isolate a single flower, ignoring other elements in the scene. In a crowd it will single out one person. It can dwell on the beauty of a distant horizon without regard for a junk heap in the foreground. It can concentrate on a lovely snowy twig while oblivious to the garish billboards that fill the background.

Your camera lens does not have the same ability to isolate elements from a visual context. The camera sees everything within view of the lens and dutifully records it. To make successful photographs you must learn to see every subject as the lens will see it, subtracting nothing. How many amateur photographers have used their every skill to make a wonderful outdoor portrait of a pretty girl

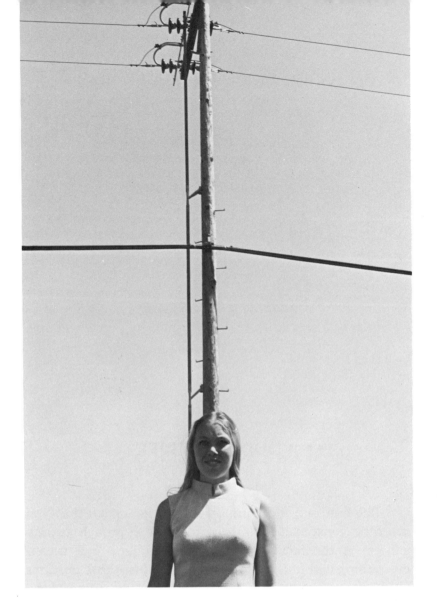

Figure 157. Unobservant choice of background.

only to find that when the film was developed and a print or slide made a lamp post appeared to be growing out of her head! So the first rule for approaching any subject is to see *all* of it, from left to right, from top to bottom and, in particular, from foreground to background.

The photography of any subject will be based finally on a pair of camera settings: the lens aperture and the shutter speed. Knowing this, the experienced photographer will always be aware, first of all, of the general level of illumination available. Bright conditions make possible the use of fast shutter speeds for hand-held work and the use of small lens-aperture settings for ample depth of field. Dim lighting conditions signal the opposite—slow shutter speeds and perhaps the need for a tripod or the use of large lens aperture settings with reduced depth of field.

118

Another factor in dealing with a subject will depend upon what, or how much, is to be included in the picture. If the scene is a landscape or seascape or city scene, what portion of it from left to right, from top to bottom, and from foreground to background should be included? Should the format be vertical or horizontal? In appraising closer subjects the question of viewpoint will enter. From where should the picture be taken? Should the viewpoint be at a somewhat greater distance to include other elements of importance to the picture, or at a closer distance to exclude unwanted elements? Should the camera angle be high or low? Knowing that your camera is not merely an instrument for recording a given scene, your concern will be with the interpretative or expressive or creative possibilities the scene may offer. You can stalk your subject, so to speak, by moving around and viewing it through your camera from a variety of possible vantage points. If you move closer you will have to keep in mind that depth of field will diminish. And in the end you may have to compromise. You may have to back off, for example, to obtain the depth of field you wish and thus be obliged to include somewhat more in your picture than you would like. Or, you may decide to stay at a closer distance and sacrifice some degree of sharpness because of depth-of-field limitations.

If the subject is a movable object or a person (or persons), other questions must be resolved. Should the subject be photographed in full shade, in full sunlight, or

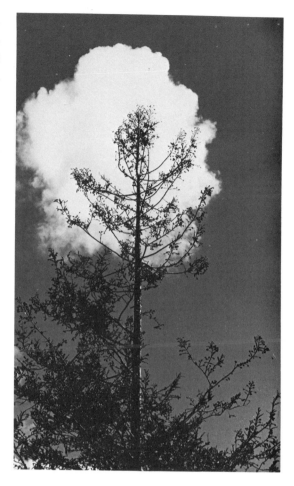

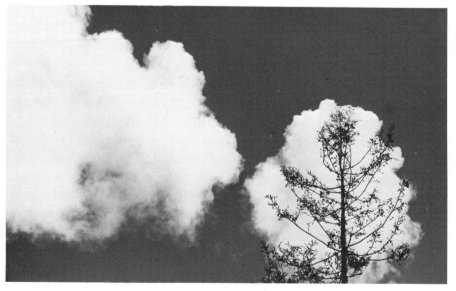

Figures 158a and b. Vertical format (above). Horizontal format (left).

some of both? What kind of background should be selected? Should the subject be posed close to the background so that the background is sharp? Should the background be substantially out of focus to create a soft backdrop against which the subject will be sharply outlined? Will some degree of under- or overexposure heighten the result? Often you may have to make compromises simply because the conditions under which you must work do not permit you all the freedom of choice that you might want.

The need to compromise comes up frequently in photography simply because a camera lens is not an all-seeing eye that can capture on film anything and everything that you can see through your viewfinder. In the last analysis there are pictures that are simply impossible to make because of limitations imposed by lighting conditions, by depth-of-field limitations, by subject motion, or by strictures on freedom to change the viewpoint from which the picture can be made.

In learning to understand your camera, a good deal can be accomplished by constantly examining the appearance of the world around you through your lens without actually taking any pictures. Simply consider this problem: What if I had to make a photograph of such-and-such a scene? First of all, how much light is available? What viewpoint, camera-to-subject distance, and camera angle should I use? How much depth of field do I need? What lens aperture will achieve this? At this lens aperture, what shutter speed will be needed? With this combination of settings can I shoot with the camera hand held or will I need a tripod? Is any part of the scene in motion? Will the shutter speed I have selected freeze the motion? Exercises like this can do much to improve your familiarity with your camera. The value of these exercises is in learning about the limitations that might confront you without the cost of wasted film. As your knowledge improves and you become practiced in thinking in terms of how your lens sees a given scene, you will become more skilled at appraising scenes for their photographic possibilities or impossibilities without having actually to look through your camera. Your eye and your judgment will continue to improve.

XVI. Understanding Accessories

TO HAVE OR HAVE NOT...

The number of accessories offered by manufacturers of single-lens reflex cameras is impressive indeed. Many of these accessories can be very useful in extending the range of your camera's capabilities. Most, however, are "optional extras" rather than necessities unless, as is the case with many professional photographers, your camera work is either extremely diversified or extremely specialized.

The most important single accessory that comes with your camera at no extra cost is the *lens cap*. The lens on your camera is very delicate and needs the protection afforded by the lens cap at all times when it is not actually in use. Not only is high quality optical glass much softer than ordinary glass but the surface of your lens has an extremely thin coating of a substance that improves light transmission. It is therefore very important that the lens be protected from any possibility of becoming scratched or smudged.

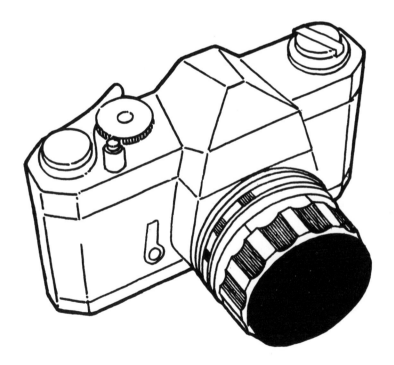

Figure 159. The lens cap.

Figure 160. A camera case.

Figures 161a and b. Having your hand through the neck strap at all times can prevent dropping your camera.

A second important accessory, which is sometimes included in the price of a camera, is a case. The value of a case for protecting your camera's external controls from dust, moisture, or accidental damage is obvious. Because of the need to remove the camera from its case to unload and reload it, some camera users prefer to work with their camera out of the case, returning it to the case after their shooting is done.

Attached to the case (or attachable directly to the camera body) will be a neck strap—an accessory that should always be used to prevent your camera from being accidentally dropped. When handling your camera it is advisable to have your hand *through* the neck strap at all times. Should you fumble, the neck strap will prevent your camera from falling.

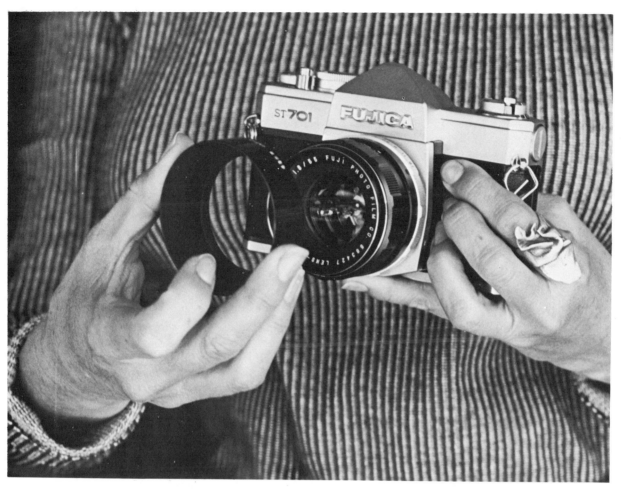

Figure 162. Putting on a lens hood
(shade).

Figure 163. Tiny battery used to
power a built-in light meter.

A third accessory of importance may cost a few dollars but is well worth the investment. This is a *lens hood* or *lens shade*. A lens hood is simply a cylinder of metal, or sometimes rubber, which has a black matte surface and which attaches to the front of your lens. Its purpose is to shield the lens from direct light rays that might degrade the quality of the image.

If your camera is equipped with a built-in electronic light meter, one more accessory becomes important. Such meters are powered by tiny batteries, which, like most batteries, will in time become exhausted. It is therefore important to have a spare battery with you at all times. These tiny batteries are extremely sensitive to corrosion and hence should never be handled. When replacing a battery, handle it with a piece of clean tissue.

123

Figures 164a and b. Flash-attachment terminals.

The acquisition of additional accessories will depend on your needs in terms of the kinds of photography you want to do. Most photographers would probably agree that a tripod is the next most important general purpose accessory to own along with a suitable cable release. These accessories have been described in the chapter on *Movement*.

When using black-and-white film, a number of interesting effects can be created by using light filters of different colors over the lens. There are relatively few circumstances in black-and-white photography, however, when the use of a filter is a genuine necessity. With color films the use of certain filters is often desirable and sometimes quite necessary. Which filters one uses will depend on the brand and type of color film used. Recommendations on the use of filters are given in the data sheet enclosed with the film.

Another accessory that you may find desirable is a *flash attachment* or *flash gun*. Flash attachments are of two types. One type uses flash bulbs that are for one time use. The other type employs an electronic flash tube with which large number of precisely controlled, repeated flash exposures can be made.

Your camera is equipped with two small electrical terminals for attaching either type of flash attachment to your camera. The location of these terminals varies among different makes and models of cameras. These terminals are wired in such a way that when you press the shutter

124

release the flash is discharged precisely at the moment the shutter curtain is open.

Since the behavior of the two flash systems in relation to the shutter action is quite different, the two terminals are identified as to which one should be used with which system. One terminal is usually marked "FP," which stands for "focal-plane flash bulb" and the other is marked "X," which stands for "electronic."

When using focal-plane flash bulbs, a variety of shutter speeds can be used. The data sheets that come with films and your owner's manual provide ample data on exposure control for using flash bulbs. With electronic flash, however, one specific shutter setting is recommended and is designated on your shutter-speed dial with a special mark or an "X." With most single-lens reflex cameras the electronic flash setting is 1/60 sec. This does not mean, however, that the actual exposure is 1/60 sec. in duration. With electronic systems the duration of the flash is extremely short and may even exceed your fastest shutter speed—for example, 1/1500 sec. or less. Thus while your camera shutter is open for 1/60 sec., light from the electronic flash only illuminates your subject for a tiny fraction of that time. Because of its short duration, electronic flash can be a very effective means for "freezing" motion.

Certain other adjuncts to your camera equipment that are not truly accessories but that have considerable importance are described in the following chapter on *Maintenance.*

There is one very special kind of "accessory" that does not cost very much money. You will hopefully never have to use it, but should the need ever arise it will repay its cost many times over. This is an all-risk insurance policy on your equipment. A good single-lens reflex camera represents a sizeable investment, and many of the accessories you might eventually add, such as wide-angle and telephoto lenses, can easily run the total investment up to many hundreds of dollars. This is an outlay well worth protecting. If you have purchased your equipment at a "duty-free" port for prices much lower than those prevailing in your own locality, do not insure your equipment for the bargain price you paid for it. Insure it instead for the full list price you would have to pay to replace it. Your insurance policy will not pay the round-trip cost of travel to the nearest duty-free port!

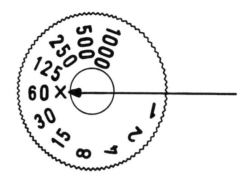

Figure 165. Shutter-speed dial marking for electronic-flash synchronization.

To insure your equipment you will have to provide your insurance broker with the serial numbers of both the camera body and the lens. The serial number of the camera is usually engraved on the top plate and may be several digits in length. The serial number of your lens will be found on the front along with the trade-name, focal length, and maximum aperture markings.

One final cautionary word on accessories: during the initial process of learning to understand your camera, it is best to concentrate simply on your camera in relation to the fundamentals of photography that have been described thus far. Do not complicate the situation by adding any of the many glamorous accessories available. These can come later.

Figure 166. Cleaning dust off a camera body with a camel's hair brush.

THE PREVENTION OF MALAISE

As with any mechanical device, consistently high performance from your camera depends upon maintaining it at a consistently high operating condition. While all internal and external moving parts and controls on your camera are important, two in particular deserve critical attention and care at all times. These are the lens and the shutter.

One of the commonest hazards to which a camera can be exposed is dust. Dust or dirt particles can cloud the lens surface and insinuate themselves into the mechanisms of external working parts. The first rule for maintenance therefore is to *keep your camera clean at all times.*

The body of the camera can be cleaned with a camel's hair brush. Do *not* use this brush on the lens surface. Camel's hair brushes are often recommended for removing dust or lint from a lens because they are soft and will

127

Figure 167. Camel's hair brush in a "lipstick" type container for protection.

Figure 168. Small hand syringe for removing dust.

Figure 169. Lens tissue specially manufactured for cleaning lenses.

Figure 170. Lens cleaner.

not scratch the surface. However, camel's hair readily picks up oil from other surfaces, including your fingertips. This oil may then be deposited on the lens surface. A camel's hair brush may be used on a lens if:

1. It is of the type that is contained in a metal case like a lip-stick container, which completely encloses it.
2. It is *never* used to clean anything else but the lens.
3. It has never been touched by your fingertips.

Because of the delicacy of the surface of a lens, care must be taken never to touch it accidentally nor to allow anything else such as the flap of your camera case to touch it. Should dust or dirt accumulate on the lens surface, or should you have the misfortune of accidentally planting a fingerprint on its surface, it can be cleaned by the following method:

1. Obtain a small rubber-bulb syringe.
2. Use the syringe to blow any surface dust off the lens, particularly around the edges. Be careful not to touch the syringe tip against the lens surface.
3. Obtain a supply of a special product called *lens tissue*. This is a tissue that is extremely soft and relatively lint-free.
4. Obtain a small plastic vial of another special product called *lens cleaner*. (All three of these products are sold at camera shops.)
5. Despite what the instructions may say, do not apply lens cleaner directly to the lens. Instead, wad up a sheet of lens tissue and apply one or two drops of lens cleaner to the tissue.
6. Apply the moistened tissue to the surface of the lens *very gently,* starting at the center and working outward with a circular movement. Never move the tissue across the lens and *never* scrub it.
7. When you have reached the outer edge of the lens, discard the tissue. Never re-use the same tissue for a second cleaning. It may have picked up dust or dirt particles that could scratch the lens.
8. After any residual moisture from the lens cleaner has evaporated, blow off any residual lint particles with the syringe.
9. If the lens is still not perfectly clean, repeat the procedure.

128

Never use water, condensation from your breath, ammonia, solvents, commercial glass cleaners, toilet tissue, facial tissues, lens cleaning cloths used for eye-glasses, or any other product. Use *only* the products and procedures described above.

If you have accessory filters, remember that these, too, are high-quality precision-made optical products that, when placed over your lens, become a part of the total lens system. They are not mere pieces of colored glass that you can clean the way you would wash a window. They must be cleaned in exactly the same way and with the same products and care used to clean your lens.

If you should have occasion to remove and replace the lens in your camera, certain important precautions must be observed if this is to be done safely.

1. Remove the lens in a clean environment to prevent airborne dust from entering the camera.

2. If you must remove the lens when working out of doors, shield it from dust-bearing air currents.

3. When the lens has been removed, immediately place the camera face down on a smooth, dust-free, and lint-free surface to prevent dust from entering, or place something over the opening that will serve as a temporary cover. Do not cushion it in a sweater or other linty garment. Remember that one thread of lint in a camera can ruin many pictures!

4. In exerting the force needed to remove and replace a lens, do not grip any of the moving parts on the lens barrel such as the diaphragm ring or the focusing ring when turning the lens.

5. Be sure the rear surface of the lens is clean and dust-free before replacing the lens.

Figure 172. NEVER place a camera without its lens on ANY surface where dust or lint might get into the camera body.

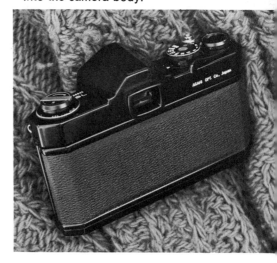

Figure 173. Half-cocked shutter indicating the end of a roll of film has been reached.

To turn now to shutter maintenance, the shutter mechanism of your camera, which consists of a number of moving parts, is subject to wear, but if properly cared for it will function accurately over a long period of time. Shutters are operated, for the most part, by means of springs. Cocking the shutter creates tension, just like stretching a rubber band. This creates the force that actuates the shutter mechanism when you press the shutter release. Once the release is pressed, the tension is dissipated and the mechanism is once again at rest.

When a rubber band is stretched for a long period of time it loses its strength and resilience because of the prolonged state of tension. The springs that operate a camera shutter behave in an analogous fashion. If the shutter is left cocked for long periods of time, the springs will eventually become weakened. Should this occur, the springs no longer have the strength and resilience to drive the shutter as fast as they should. This slowing down will cause the exposure interval to be longer than a given setting indicates. If, for example, at a shutter speed setting of 1/60 sec. the actual exposure interval has been reduced to 1/40 sec., the film will actually be receiving half-again too much exposure.

130

There are four rules to follow for proper shutter maintenance:

1. Never leave your camera shutter cocked for any extended period of time. In particular, do not put your camera away with the shutter cocked. Each time you end a shooting session be sure that before you close your camera case the shutter has been released, even if this means wasting a frame of film.

2. You will find that when you reach the end of a roll of film you may be able to cock the shutter part way before tension on the film-advance lever tells you that you have come to the end of the film supply. After rewinding the exposed film and removing it from the camera, remember that your shutter was left partially cocked. Cock it the rest of the way and release it.

3. If you discover that, inadvertently, your shutter has been left cocked for a long period, it would then be advisable to take it to your dealer or a camera repair shop and have the shutter speeds checked for accuracy and adjusted if necessary.

4. Periodically, depending upon how much you use your camera, you should have a shutter-speed check made and have the camera thoroughly cleaned.

In addition to dust and dirt, another major enemy to avoid is moisture. Keep your camera dry at all times. In particular, be cautious around salt water. Salt spray can be very corrosive to metals and can penetrate through the edges of external camera controls to cause hidden damage.

Condensation is another moisture hazard. If you have been shooting outdoors in very cold temperatures, when you come indoors into a warm environment be careful not to remove your camera from its case. Humidity in the air will immediately coat all exposed metal and glass surfaces with a film of moisture. Instead, wait a while until your camera has come to room temperature.

High temperature is another hazard to avoid. It is particularly dangerous to films. Where- and whenever possible shield your camera from excessive heat. Do not leave it lying in a place where it will be exposed to hot sunlight, or store it in a place where a high temperature might prevail. For example, don't store your camera in the glove compartment of a car. Always try to keep it in a cool, dry place.

Figures 174a and b. After the camera has been unloaded, the shutter should a) be cocked the rest of the way and b) released to remove spring tension.

And one final cautionary word: never oil any moving part on your camera in the mistaken belief that this will help to keep things running smoothly. All that oil will do is to make parts sticky and cause dust and dirt to accumulate.

A camera, unlike certain brands of widely-advertised watches, is not heat-proof, water-proof, dust-proof, or shock-proof. But, like a fine watch, it is a precision instrument. Its care rests in your hands.

THE FINAL STEPS

When the first cameras utilizing 35mm film were introduced nearly 50 years ago the name "miniature camera" was coined to distinguish them from their larger brethren. Such miniature cameras took miniature pictures. The state of the film manufacturing art in those days did not permit any great degree of enlargement of such miniature pictures. Hence the results at best were still miniature, relatively speaking. The situation today is quite a different one. With modern lenses and films a great degree of enlargement is possible before any loss in quality becomes noticeable.

The excellence of modern color films is such that a great many users of single-lens reflex cameras use color film to obtain slides. Such slides, to be fully enjoyed, must be projected to a size large enough for comfortable viewing. Projection is thus the most widely used form of presentation. If, however, this form of presentation is to do justice to the excellence of the slides that a good single-lens reflex camera is capable of producing, certain conditions must be met.

In the first place, the slide projector you use must be of excellent quality. There is simply no point in owning a precision camera if the presentation of your results is done with a cheap, poor-quality projection device. Such devices have inferior lenses that effectively cancel the excellent quality of your camera lens. They may also have poorly designed illumination systems with inadequate ventilation, which can seriously damage your slides through excessive heat. The mechanism that transports the slides in and out of the projector may cause irremediable scratches. Even the color of your slides may be distorted. Good quality projectors are more expensive, but they can make a tremendous difference in the quality of the presentation of your work.

The second point to consider in presenting images by projection is the surface on which the image is to be projected. There are special screens designed specifically for this purpose, which are available in a variety of sizes from photographic supply houses.

With a good projector and a good screen there are still other factors to which proper attention should be paid. The most important is alignment. Although most slide projectors have a means for elevating the front end in order to raise the image higher on the screen, this introduces a form of distortion called the *keystone effect*. Not only is the screen image non-rectilinear but there is the additional problem caused by the fact that the distance from the projector lens to the bottom and to the top of the screen image are unequal. This can make it difficult to get the entire image in sharp focus. The table or stand on which the projector is placed should be approximately the height of the center of the screen so that the slide and the screen image will both be perpendicular. Also, in lining up the projector with the screen you should take care to make sure that the slide and the screen are parallel to each other. If you do not, a horizontal version of keystone distortion will be introduced.

Slide projectors are available with lenses of different focal lengths and lamps of different intensities to suit particular conditions. For example, a slide projector for home use may have a relatively short focal-length lens in order to provide a sizeable image in a relatively small space. The wattage of the lamp will be relatively modest, in keeping with home-use conditions. A projector for use

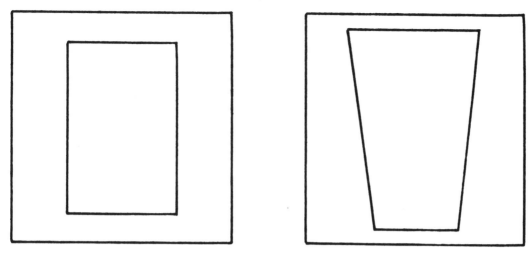

Figure 175. Rectilinear image (left), projector and screen correctly aligned. "Keystone" image (right), projector tilted upward.

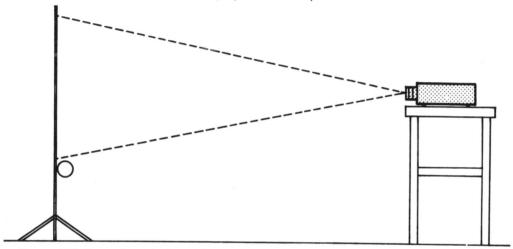

Figure 176. Correct vertical positioning of projector and screen to insure a rectilinear image.

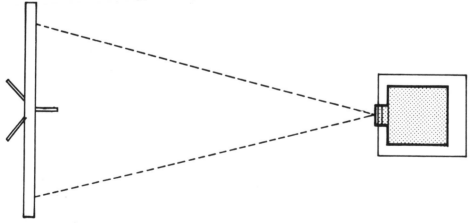

Figure 177. Correct horizontal positioning of projector and screen to insure a rectilinear image.

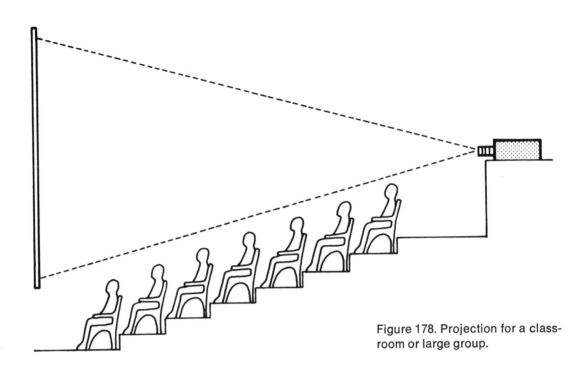

Figure 178. Projection for a class-room or large group.

in a large lecture hall will have a longer focal-length lens to provide a large image at a considerable distance and will have a lamp of much higher wattage to project a bright screen image over a long distance. If such a projector were used at short range in the home the projected image would be relatively small and too bright for comfortable viewing. Before purchasing a projector for home use, select an area in your home that will be suitable and comfortable for slide viewing and measure the distance between the points where the projector and the screen will be placed. Your dealer will then be able to make recommendations on the type of projector, the focal length of the lens, the lamp wattage, and the screen size that will come closest to meeting your requirements.

Another aspect of presentation has to do with viewing distance. Set up your projector and screen, put a slide in and focus the screen image to maximum sharpness. Then walk slowly forward toward the screen, observing the image carefully as you go. You will presently reach a point where the greatly magnified screen image begins to appear unsharp. The closer you move toward the screen the more unsharp the image will be. Now move back from the screen until you reach a point where the image is at a sufficient distance to appear uniformly clear and sharp.

136

Make a note of this distance and be sure that no member of an audience to whom you will show your slides is closer to the screen than this distance.

Before you show a collection of slides, make sure they are in proper sequence and proper orientation. In a word, if you have done good work with your camera, be sure to present it in the best possible way. A guaranteed way to create impatience, irritation, and eventually boredom in your audience is to show slides that are upside down or reversed from left to right and to constantly interrupt your presentation while you correct your mistakes!

If you work with black-and-white film or color negative film, the usual form of presentation will be an enlarged print on paper. Owners of single-lens reflex cameras who work extensively in black-and-white frequently do their own developing and printing and hence can exert a good deal of control over the final presentation. When enlarging prints the same principle that was stressed with respect to slide projectors applies with equal force to enlargers. The quality of the enlarger, and in particular, its lens, must be high enough to do justice to the high quality of the negatives your camera can produce. A poor quality enlarger lens can negate all of the advantages of a high quality camera lens.

Enlarging prints introduces one advantage in presentation that the slide-maker does not enjoy. This is the ability to "crop." Cropping is the deliberate elimination of unwanted portions of a picture along any of its four sides. For example, a given subject might best be presented in a square format rather than an oblong format. Often there are situations in which circumstances will oblige you to include more in your picture than you would really like. In the enlarging process, unwanted details of composition or distracting areas such as an out-of-focus foreground can be easily eliminated.

One of the most important aids in the presentation of enlarged prints is mounting them. If you compare an unmounted print with a mounted one you will immediately notice the very considerable difference between the two modes of presentation. Photographic prints are best mounted by means of heat-sensitive *dry-mounting tissues,* which can be obtained from photographic supply houses. Ordinary adhesives should be avoided since they may contain chemical substances that will attack the

image and cause discoloration or fading. The stock on which a photograph is to be mounted is also an important factor. The best quality materials obtainable should be used. Cheap cardboard stocks often discolor from exposure to light. The best sources for high quality mount board are art supply dealers.

Above all, work cleanly. The presentation of your prints will not be helped if your prints or your mounts are marred, scuffed, or improperly trimmed.

Figure 179. An unmounted (left) and Figure 180 a mounted print (above).

XIX. You and Your Camera

Paradoxical as it may seem, it is fair to say that most of the thousands of owners of modern single-lens reflex cameras never use their cameras to *make photographs.* They merely use them to "take pictures." There is a world of difference between taking a picture of something and making a photograph of it. This in large part *defines* the difference between "snapshooting" and creative photography.

A photograph is a graphic record of something in front of the camera. However, it can also be a graphic record of something behind the camera—the photographer. Although completely out of the view of the lens, the photographer can put a good deal of himself into every photograph he makes, either subtly or with great force. At one pole, the question will simply be: What do I want to *record* with my camera? At the opposite pole the question will be: What do *I* want to say about the subject in front of my camera?

If, with a clearer and fuller understanding of your camera, you still view the world around you simply as one containing *objects* to take pictures of, you will still fall far short of using your camera to its fullest capability. In your hands your camera can cease to be a recording instrument and become instead a highly versatile instrument for *expression,* for *interpretation,* and ultimately for

creation. But, to do this, you must first learn to regard everything you might wish to photograph as a *subject,* that is to say, something in which you sense some degree of direct personal response, interest, empathy, concern, or excitement. To make good photographs of any subject, there must be some degree of personal involvement, conscious or unconscious, which will prompt you to transcend the mere recording function. Your camera, thoughtfully used, has rich possibilities for expressing what you think and what you feel about what you point your lens at, and hence what kind of a photograph will result.

A thoughtless photographer, on coming upon a scene of great natural beauty, will say, "Oh, I *must* take a picture of that!" Snap! A record has been made. A thoughtful photographer will say, "Yes, it is very beautiful, but I see no way I can photograph it that will convey something of my feeling for this subject *in the photograph.* Or, after appraising the scene, he might say to himself, "If I come back in a few hours when the light is low, the shadows are long and the colors are warmer in the late afternoon sun, a photograph might then be possible."

Let us take another example—making an outdoor portrait of a girl with delicate features, a light complexion, and long blond hair. The thoughtless photographer will take the girl out into bright sunshine (after all, he needs light!), stand her against a background (often ill-chosen) like a prisoner before a firing squad, and "shoot" her. A single exposure and the job has been done. But, the delicate tones of her skin will be lost in the glare of direct sunlight and the shadows cast by her features will be harsh and contrasty. The thoughtful photographer, on the other hand, will recognize at once that her blondness is a very important aspect of her appearance that must be appropriately dealt with in his photograph. He will then spend a little time getting acquainted with his subject to get some "feel" for her personality. He will watch for characteristic facial expressions. He will be watchful for other expressive characteristics as well. For example, does she use her hands expressively, and if so, he will consider how best they can be included to enhance the portrait he wishes to make.

When it comes to photographing her he may place her in full shade in order to minimize contrast and preserve a soft gradation of tone. He may select a dark background

140

against which her blondness will be heightened, or a light colored background to harmonize with her blondness. Before making photographs of her he will study her through the camera lens from different viewpoints, different distances, and different camera angles. He will try right profile, left profile, full face, and many angles in between. Although her blondness is a dominant *visual* characteristic, his sense of her personality may be one of richness and color. To convey this feeling he might deliberately use some degree of underexposure to deepen her coloring slightly. If, on the other hand, his sense of her personality is one of delicacy, fragility, or buoyancy, he might choose to overexpose his film somewhat to achieve a heightened feeling of lightness and translucency in the tones of her face and hair. If, however, despite her visual beauty, her personality conveys a feeling of coldness, shallowness, or guardedness, he might then use a substantial degree of overexposure to eliminate subtle textures and tonal gradations from her face, thus creating an effect of flatness, emptiness, and opacity. And the thoughtful photographer, knowing well that he is working with a living, breathing, moving, ever-changing subject will also know that unless he should be extraordinarily lucky he will never succeed in making a photograph that has the particular qualities he seeks in a single exposure. He will make a series of exposures.

Examples of the two different approaches—that of the thoughtless photographer who takes pictures and that of the thoughtful photographer who seeks to make photographs—can be multiplied endlessly because the essential differences between the two approaches are common to every situation and subject. The thoughtless photographer puts nothing of himself into his photographs and often little enough of his subject. The thoughtful photographer includes not only his subject but something of himself as well in his photographs.

Between these two ways of approaching a subject lies one that we might call the "mixed approach". Examples of the mixed approach exist in countless numbers and are at the top of the list of pictures guaranteed to bore other viewers. A typical example would be the case of a photographer who has come on a scene of impressive natural beauty. The elements that will go into his photograph include a point of view that has been well selected, a

strong and interesting composition, an appropriate selection of lens aperture and distance to achieve ample depth of field plus a fast enough shutter speed to insure a brilliantly sharp result, and, to complete this technical *tour de force,* an exposure that has been accurately determined. But, just before making his exposure, the photographer has added, in the worst sense of the phrase, something of himself that completely destroys his photograph. In the near foreground, dominating the scene, he has placed his wife, mother-in-law, a bored child or two, and the family dog, with everyone but the dog wearing that ghastly grimace that usually results when people are obliged to smile on command!

There is, of course, a certain feeling of natural sentimentality in all of us that prompts a desire to have photographs of our family, our friends, and ourselves in settings that we visit in our travels. While this in itself is a perfectly valid use of a camera, the error in the mixed approach lies in trying to accomplish two very different things simultaneously on one piece of film. If you must have a "See, we were there" picture—a personal trophy, so to speak, of your travels—well and good. But first do the best job of photography you can with the subject matter before you. Then take one final picture with your retinue included. In a word, don't mix the expressive, the interpretative, and the creative aspects of photography with the recording function. While both have their place, the two are seldom compatible unless combined creatively and with the greatest finesse.

You and your camera together form a kind of partnership, the same kind of partnership that exists between any craftsman and the tools of his craft, whether he is a carpenter, a lithographer, a surgeon, or an auto mechanic. Your camera is a highly refined precision tool for taking pictures, but only through your guidance does it become the means for making photographs. While you cannot make photographs without your camera, remember, your camera is mindless. This makes you the senior partner in the firm. If thoughtfully directed by you, the partnership will flourish and the rewards will be great.

YOU AND YOUR CAMERA

Over the past two decades there has been a general and growing standardization in basic camera design. Whereas at one time compact cameras came in an endless variety of designs, today the type known as the "eye-level 35mm single-lens reflex" camera has become pre-eminent the world over. The "SLR" is the most popular and widely used camera among professionals and amateurs alike.

This book makes clear and simple the principles, concepts, and functions of all cameras, particularly those of the single-lens reflex design. Here you will find no jargon, no abstruse language concerned with *refractive indices* or *gamma infinity;* on the contrary, the goal of this book is to demonstrate that understanding of your camera and its functions is easily attainable. From the clear descriptions of the camera's controls— what they can or can't do for you —to the simple, step-by-step explanations of how to *use* these controls to make the best possible pictures, the book translates the technical into the understandable for all who would like to exploit with freedom and enjoyment the remarkable capabilities inherent in modern cameras.

The Author
William R. Hawken

Professional photographer/ writer/consultant William R. Hawken has had over thirty years' experience in the photographic field. During 1947-59 he was the head of the Library Photographic Service at the University of California, where he was also Visiting Professor during 1969. During 1960-68 Mr. Hawken was consultant on document reproduction to the American Library Association. He has written many books and articles on photocopying, reprographic, and microfilm technology. Mr. Hawken is presently running his own consulting firm in California, and is a Fellow of the Institute of Reprographic Technology and the National Microfilm Association.

Write for free catalog of photo books

AMPHOTO
American Photographic Book Publishing Co., Inc.
Garden City, N.Y. 11530